# DRAWING PORTRAITS: FU

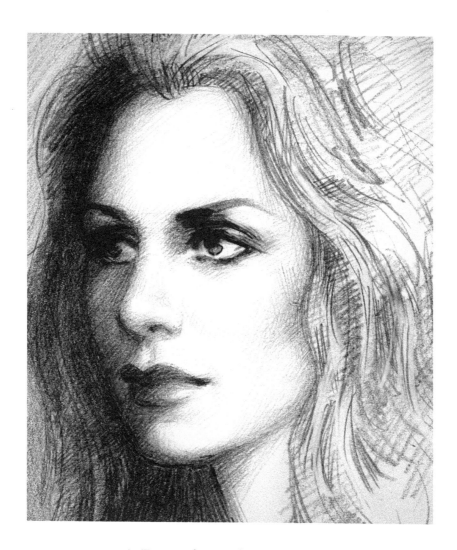

## A Portrait-Artist.org Book
## (How to Draw People)

### J R Dunster

ISBN: 0-9754564-0-7

ISBN-13: 978-0975456408

**Green Verdugo Press**
Gverdugo.com

# DEDICATION

To my family. Thank you for your continued love and support.

*Detail of "Classic Profile" (left, oil on canvas panel), "Eleanor" (center, pencil on paper), and "Exotic Simplicity" (right, oil on panel), © JR Dunster*

*Drawing Portraits Fundamentals* was written to accompany my tutorial site, http://portrait-artist.org. While some of the book is derived straight from the site, there is a lot of content that is original to this book.

The first edition was published and sold via a print-on-demand publisher, all the way back in 2004. For years I kept on promising site visitors (and myself) that I'd write a second edition and make it available through more mainstream avenues (like Amazon, B&N). But, the time didn't seem right, until now.

I'm very excited about the second edition! New artwork has been added, I have replaced some images, as well as edited, modified, and included some new chapters and passages. While I'm proud of the first edition, I believe that a lot of quality and value has been added to this second edition.

This book discusses such topics as: making up faces from your imagination, anatomy, dealing with discouragement, formal education, competition, introduction to color and painting, values and shading, drawing more realistically and accurately, working from life, and so much more.

To get more updates about the book, learn about upcoming books, and also to get some freebies, please go to **portrait-artist.org/book**.

# TABLE OF CONTENTS

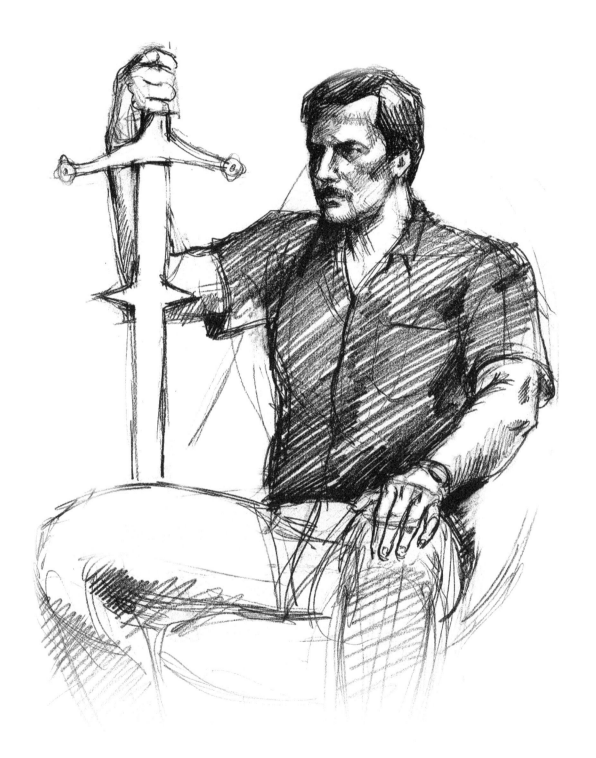

*"Bill with Sword," drawn from life. Pencil on paper.*

# ACKNOWLEDGMENTS

There are a lot of people to thank, and this is the page to do it.

My eternal gratitude to my father, who, after a long day at work, would drive me home from art school every evening. Even with all the generous, amazing things that you did, dearest Father, those nightly drives seem to stick with me the most. I once told you that I would write a book about drawing, and now I have. Thank you.

Thank you dear Mother, for helping me edit this book, and for always being so enthusiastic.

Thank you to Karen, Arlene, Barbara, & Marge. You have all helped and encouraged. Much gratitude to the Wolves, Randy, Joyce, and Sheryl as well. A special thanks to Bill, who has repeatedly pushed and encouraged me, and always with such wisdom. My love and gratitude goes out to all my teachers, starting with the first and best, Shirlee Prescott Morgan. Thanks to all the teachers at Glendale Community College of Glendale, California, as well as my instructors at Otis College of Art and Design of Los Angeles.

There are so many others to thank, and you know who you are.

Oh, and thanks to Zevia Lime Cola, Cactus Cooler, and Jerry Goldsmith. I wouldn't have made it through this book without drinking you (in the case of the Zevia and Cactus Cooler), or listening to you (in the case of Mr. Goldsmith).

Finally, this page would not be complete if I did not express my profound gratitude to the good Lord for always helping me in my life and with my art.

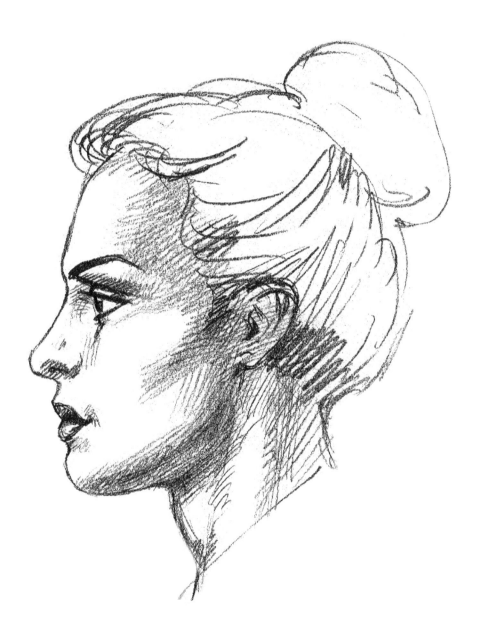

"Young Woman" pencil on paper.

# WELCOME AND INTRODUCTION

*Drawing Portraits: Fundamentals* has been written to be a companion book for my Website, portrait-artist.org. Some of its content is derived from the Website, but many additional illustrations, clarifications, and extra chapters have been added. Portions of the site were excluded for a variety of reasons—for instance, some tutorials regarding color were removed because this book is printed in black and white.

I created portrait-artist.org with several thoughts in mind. My main priority was to help "newbie" (beginner) artists who are feeling a little uncertain about this "art thing," especially with drawing faces. I remember very well when I first discovered that I wanted to draw portraits. I felt such frustration at times because I *knew* that there was so much more to learn but I didn't know where to begin. All these years later, writing a portrait art tutorial has been cathartic—I figured that if I could help others avoid some of the mistakes I had made when I first started out, then maybe all my struggles back then would not have been in vain.

Another reason I wrote this book was to share my love for art and drawing. Art is something that can transform a person's life and strengthen their feelings of self-worth and confidence. When more people are encouraged to nurture their interest in art, the more people will feel this happiness and satisfaction.

As this is the second edition of the book, a few things have been changed. I replaced some of the original graphics with new (hopefully improved) images. The section about digital art was refreshed as well. (My goodness, how much can change in over a decade!) There are other things that I've edited, deleted, and added to the book.

## How this book is organized

It has been a challenge to decide how to organize the tutorials for this book. On the

Website it wasn't as much of a concern, because the visitor could read the site's content in any order they desired. The difference with a book is that it is conventionally read from start to finish. Therefore, the order in which things are placed is much more important.

The first few lessons in this book cover drawing fundamentals. These lessons have been included for those who have little drawing experience. While I've tried to cover the essential basics of drawing in these lessons, any student with little or no drawing experience is encouraged to read other beginning drawing books. (I recommend *The New Drawing on the Right Side of the Brain*, by Betty Edwards.)

The middle part of this book contains the meat of the topic at hand: nuts-and-bolts tutorials and lessons covering the structure of the head, advanced shading techniques, and step-by-step lessons on drawing the face. I wrote these lessons in hopes of helping you understand how to draw faces better—whether you draw from life, from a photograph, or even from your own imagination.

The third and last section contains mostly "essays" which discuss other issues and topics that artists must face, as well as some "arty philosophy." While these essays are not mandatory reading for the artist who wants to learn how to draw portraits, I do hope that you will read them. There is more to an artist than learning how to make creative lines— we have to live in the real world too, and we face real world challenges!

I emphasize that even though this book does cover the simple fundamentals of drawing, the more drawing experience a person has, the more they will get out of the later (and more advanced) lessons. However, if you, the reader, find it easier to skip around, by all means, do so! But please keep in mind that some of the more advanced lessons are written with the assumption that the reader is already familiar with the information covered in previous chapters.

# SECTION ONE:

# DRAWING FUNDAMENTALS FOR THE NEW ARTIST

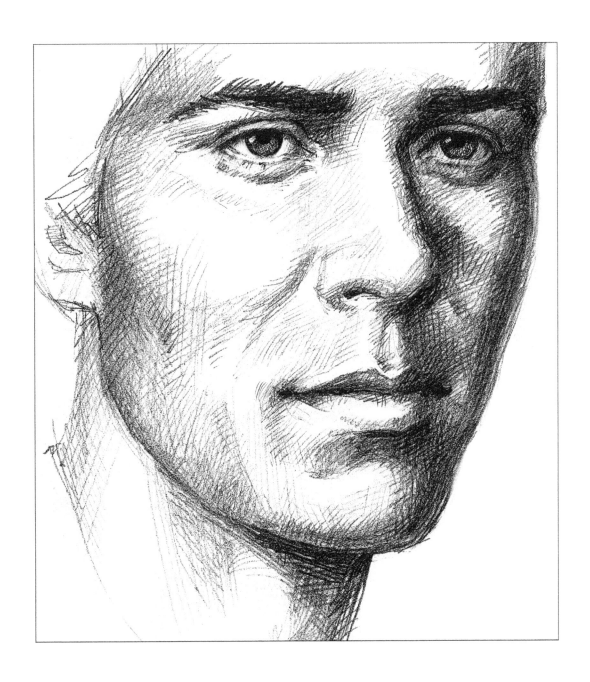

# CHAPTER ONE

# LET'S GET STARTED WITH DRAWING

## Some Introductory Words for the Newbie Artist or Artist "Wannabe"

One thing I want you to understand right away: *You can do this.* It doesn't matter if you feel "untalented"; you can do it if you want it hard enough. I hope by the end of this book you will have received enough information and encouragement to feel confident that drawing is something that is within your grasp.

Drawing is a skill that most people can learn. It is not reserved for those who are born with a "natural talent." Talent is overrated. With education, knowledge, and practice, most anyone has the potential to accurately draw what they see.

I am not saying that talent is not a great thing, nor am I claiming that talent doesn't exist or doesn't matter. I am simply telling you that drawing is a skill, like handwriting. Like handwriting, it requires practice.

Don't worry if you think you are too old (or too young) to develop this skill. Don't let any concerns about your age hold you back. As long as you have the manual dexterity to write your own name and can hold pencil to paper, you are perfectly able to learn to draw.

Have patience with yourself and enjoy the process. It is especially important for you, as a new artist, to remember that there should be no deadlines—you should not pressure yourself or expect perfection right away. Don't push yourself to do "perfect" work. I give you permission to do "silly" or "abstract" drawings too. They are also important.

Even though the rest of this book contains many tutorials that are rather specific and structured (full of "rules"), don't let yourself get too uptight about always following the rules. It's not the end of the world if something you draw doesn't turn out the way it was "supposed" to. Just do another drawing!

Most artists will tell you that throughout their artistic careers they have filled many sketchbooks with drawings—including *bad* drawings. Don't expect that you are going to be exempt from this same thing—you *will* create bad art sometimes. This is how it is for everyone, even for the artists that everybody assumes are born with a gift. I am not telling you this to discourage you—quite the opposite, in fact. I simply want you to understand that it is normal for all artists to produce some drawings that are not very pleasing to them.

## Choosing Drawing Materials

Fortunately, it is not required that you buy very elaborate, expensive, or exotic drawing materials. However, you shouldn't settle for bargain-basement art materials either. Even though a lot of the illustrations in this book are drawn in ink, I recommend that all newbie artists stick with pencil for a while. I used some ink illustrations because they reproduce well in print.

If you have decided to create artwork on the computer, it is still vitally important that you learn to draw using traditional paper and pencil. You can always digitally manipulate and edit your sketches on the computer later on.

When choosing drawing paper, you will be assaulted with a multitude of choices. There's "drawing" paper, and then there's "sketching" paper. Usually (but not always) drawing paper is a little higher in quality and therefore more expensive.

When you first start out, sketching paper should be fine. Just make sure the paper you buy can take the media you intend to use. For instance, if a paper says "pencil and charcoal," don't try to paint a watercolor on it. Some drawing papers will take ink and watercolors too, so check each type before you buy!

There are many good paper brands. I usually use Strathmore or Canson brand papers, but I have been known to get whatever I can find. (Some of the drawings shown in this book are from a sketchbook that I bought at the local dime store.) Be warned—many of the cheaper brands won't take multiple erasures well. Feel the paper between your fingers and decide if it feels thick and hearty enough to take some erasures and scratching.

Be sure to choose paper that is "acid free." This means that it will not turn yellow over the years. Don't get newsprint. It's great for certain things, but is far too flimsy and thin for portrait drawing. It will not take any erasures well and since it is rarely acid free, it discolors and starts to disintegrate after a while.

Pencils are graded by the softness or hardness of their lead. Most leads in the H range (2H, 3H) are unsuitable for portrait work. The lead is on the hard side and therefore leaves only a faint mark. Pencil leads in the B range are far better. The leads with B and 2B softness are best for starters, or you can make do with an HB if that is all you can find. A 3B or softer can be great for making dark tones, but the soft graphite will easily smear if you aren't careful.

Mechanical pencils are becoming increasingly popular among non-artists, but many artists enjoy using them too. I've been drawing with such mechanical pencils for many years. All the pencil drawings presented in this book were made with a mechanical pencil using a 0.5 mm lead. I have also started using 0.7 mm and even 0.9 mm leads, but the 0.5 mm lead is still my favorite. I usually favor B softness leads, but if all that is available is HB, that's what I'll use—I'll just bear down harder to get a dark line.

I recommend kneaded rubber eraser for pencil work. There are many different brands of these kinds of erasers, and as far as I know they are all pretty similar. Kneaded rubber erasers (available at almost all art stores) are a little like Silly Putty, the strange rubbery putty that many of us played with as children. Manipulate the kneaded rubber eraser with your hands to make different shapes. You can even make a little pointy tip to erase small and delicate parts of your drawing. As you knead the eraser, the warmth of your hands will make it more pliable. When a portion of the eraser gets dirty with graphite,

knead the eraser so that all the "dirty" spots are blended throughout the entire eraser. You can extend the life of a kneaded rubber eraser by regularly kneading it.

Regular rubber erasers (or pink erasers) are acceptable for erasing areas of your drawing that are resistant to erasures with the kneaded rubber eraser (for instance, if an area is very dark). Otherwise, regular erasers are not preferable and should only be used when nothing else is available.

When you have completed your drawing, you will need to use something called *fixative*. This comes in an aerosol can and may remind you a little bit of hair spray. Fixative spray is used to "set" your pencil drawing after you have finished. If you don't "fix" your drawing, it may smudge and smear in your sketchbook.

Read the directions on the can when using fixative. Don't spray it too close to your drawing and make sure to apply the fixative in a well-ventilated area. (The fumes are nasty!) Also be careful not to fix your drawing until you are certain you have completed it. After the drawing has been sprayed, it becomes increasingly difficult to erase. That's the whole point of fixative—to prevent the pencil from lifting off and smearing. Sometimes you can do a little bit of altering and erasing on an already fixed drawing, but it is always more difficult.

I personally would recommend avoiding the use of varnish fixatives. They seem like overkill for simple pencil drawings. Krylon brand Workable Matte Fixative is something I've used in the past—it's unique because you can keep on working on your drawing even after it's been sprayed. Winsor & Newton Artists' Fixative Spray is another brand that should be more suitable for pencil work.

## Let's Get Started with Drawing: Negative Space

Learning to identify negative space will help you learn how to draw what you see.

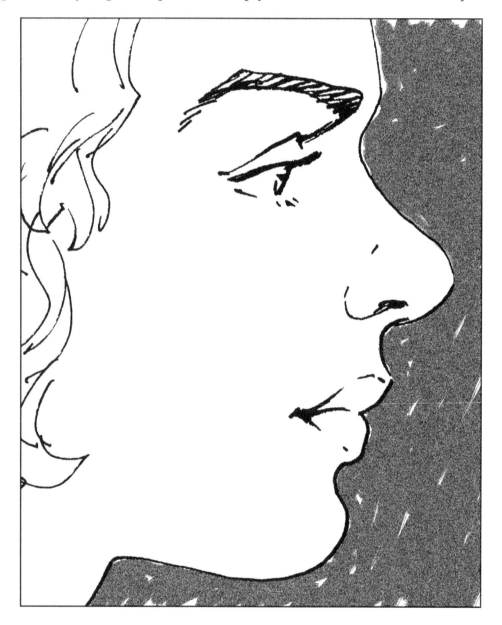

The gray background in this illustration is also something called "negative space."

"Negative space" is the area *around* the actual object that you want to draw. When you look intently at the subject you intend to draw, you will start to see these negative shapes as abstract forms. Instead of seeing a nose or a mouth, you'll see the abstract shapes that are *around* them. Because these abstract shapes share a border with the nose and mouth, when you draw the abstract (negative) shape, you'll be drawing the outline of the nose and mouth as well.

Most people, when they draw incorrectly, are allowing their brains to interpret the things they see in symbolic terms. (For instance, the symbolic but inaccurate way to draw an eye is with a simple almond shape.) These symbols are inaccurate and cause the artist to make mistakes in their drawing. The brain uses these symbolic terms and tries to override what the eyes *actually* see.

However, when you draw the negative space (an abstract shape), your brain has nothing to hold onto—it can't try to fool you with its simple symbolic way of seeing things. Therefore, you are able to draw more accurately.

As you see on the illustration on the previous page, the background of the picture is gray. The gray color represents the area around the profile. This gray area is a perfect example of negative space.

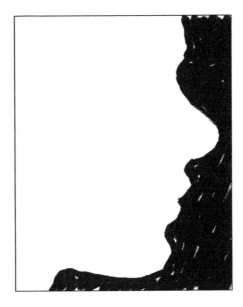

The black area in this picture is negative space. It's easier to identify the negative space when the distracting details of the woman's face have been eliminated. Stare at this black area and look at its unique shape—try to divorce your mind from the notion that this picture is the silhouette of a face. It's an interesting shape, isn't it?

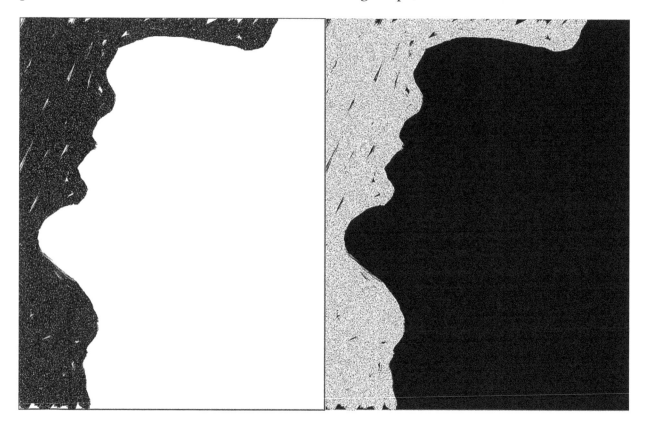

Looking at something upside down helps your brain see things even more abstractly, instead of symbolically.

Look intently at the negative space in these illustrations and continue to ignore the "profile" shape. When you focus on these interesting shapes and stop thinking about the girl's profile, you are able to let go of restrictive thoughts such as, "This is the profile of a person that I am drawing. A profile is supposed to look a certain way."

This illustration shows some typical symbolic ways of drawing things. We learned to draw some of these symbols when we were children, which explains why they have a child-like look to them.

As you are able to ignore what the analytical symbolic part of your brain is telling you and are able to let your eyes show you what you really see, you are well on your way to drawing more accurately. Recognizing negative space is one of the main secrets or tricks that artists use to draw well.

## Your first drawing assignment

Since looking at something upside down is helpful in aiding you to see things as they really are (as opposed to symbolically), your first assignment is to copy an image while looking at it upside down.

This exercise is certainly nothing new, but it is very effective. It is commonly used by students of the wonderful drawing book *The New Drawing on the Right Side of the Brain* by Betty Edwards (published by J. P. Tarcher). When you look at something upside down and try to copy just the abstract and somewhat meaningless shapes that you see, you will end up with a more accurate drawing than if you looked at that same picture right-side up. According to Betty Edwards' teachings, the left side of the brain is the symbolic side,

while the right side is able to see visual things more abstractly and correctly. The negative space exercise and the upside-down exercise are two ways to help you tap into the right side of your brain and temporarily quiet down the pushy symbolic left side of the brain.

Get a piece of blank paper and draw a box on it that is 5 inches wide and 6-1/2 inches high. Use a ruler to make this box and make sure that all the corners are even and square. Then look at the drawing on the next page and try to copy it. Feel free to erase any lines you get "wrong," but don't be obsessive about getting everything perfect. Have fun!

Look at the shapes in this picture and don't think about drawing the girl's face. Look at the border of the picture. Find the lines that touch this border and notice where they are positioned. Where are the lines at the bottom and the top of the picture placed? Are they in the middle, or nearer to the corner? Think about the placement of all these lines, but don't think about what you are drawing. Just focus on the abstract lines and shapes.

When you draw the shapes and lines of things that are not directly touching the border, see where they are located in relation to the border—is that bumpy shape halfway between the bottom and top borders of the picture? How close is it to the side border? How close is the bumpy shape to the weird squiggly line?

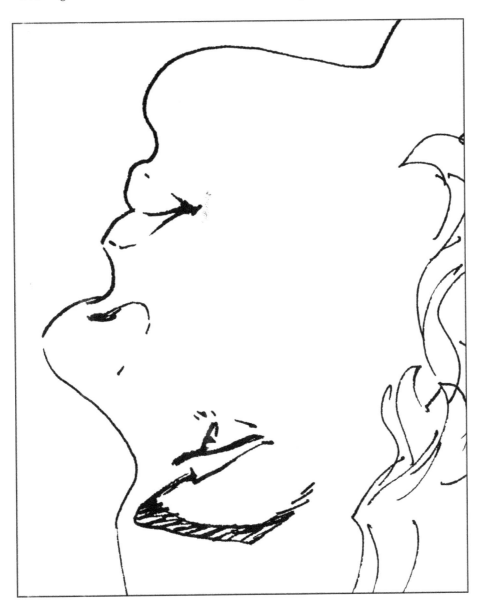

When you complete this drawing, you will probably be surprised at what you produced. Turn both your drawing and the drawing in the book right side up and see how they compare.

If you were expecting to draw an amazing example of complete accuracy, you might be a little disappointed. But if you thought that you wouldn't get the drawing even remotely close, you were probably pleased with how well you did. That's the magic of negative space!

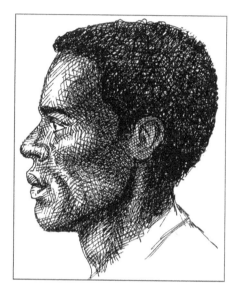

*The white area surrounding the man's head is also negative space.*

## Looking for an angle

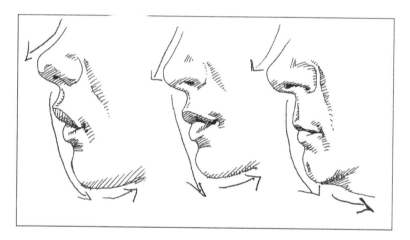

When drawing any shape or line, look for the overall angle and direction that the form is going. "Block out" basic shapes as you see them; then refine these shapes and lines as you add more detail to the drawing. In the illustration above, notice how each profile has different angles—the chin tips up, the lips dip in, the nose slopes out—each in a slightly different way. Look for these fundamental and unique angles of shapes and forms as you are drawing them.

*Blocking out the angles.*

## Using the grid and negative space

A popular tool to help newbie artists see and draw more accurately is the grid method. The way this works is that you draw even squares (a grid) all over the picture you want to copy and then put corresponding squares on your paper. If you want to size the picture up for your drawing, you can make larger squares on your drawing paper. All that is important is that all squares are perfectly even on all sides.

After you get the grids drawn in on both the picture and the drawing paper, you match each square on the picture you want to copy to a square on your sketch paper. This helps you break down the picture into smaller segments. You then copy what is in each square, individually. Using this method, you are more apt to get things placed in the right spot and in proportion. This can be very encouraging to the beginner artist!

Also, when you copy what's in these squares individually, it will help you see the negative space of the portion of the image that's in each square. This will further train you to be able to draw what you see.

Draw a box that is 6 inches wide by 6 inches high. Start making 1-inch squares (perfectly straight and square—use a ruler to do this) starting at the top left corner. Then, use the illustration on the following page (which already has the correct amount of grid squares on it) and see if you can match up everything in each square. Number your squares the same way the illustration has the squares numbered, to make it easier to locate and match which grid square you are working on. After you've finished filling in all the grid squares, carefully erase each line that made up the grid. What you will have left will be a fairly accurate drawing of a man's profile. Cool, huh?

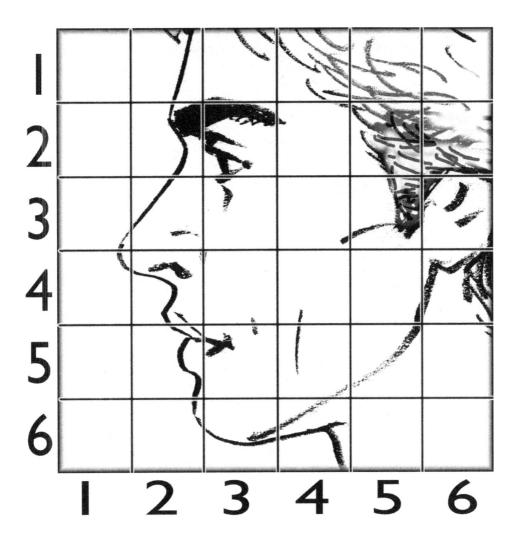

*The drawing with some typical grid lines drawn over it.*

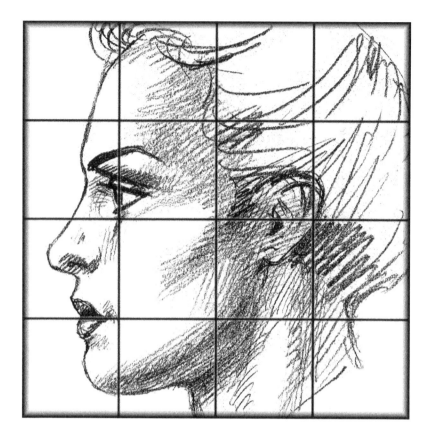

Of course, once you do a number of drawings with the smaller-proportioned squares (as seen in the first gridded illustration), it is probably a good idea to start using slightly larger squares, then even larger, and so on. Consider the grid method as a process to help you to learn how to draw more accurately on your own.

The larger the squares are in your grid, the more drawing and *seeing* you will have to do in order to get the drawing correct. Each square is bigger, so you have to work harder to fill up each square accurately.

If you were to stick with the smaller squares for your drawings, you'd get to a point eventually where you'd start to stagnate or not learn anything new. By gradually using bigger squares (and then eventually graduating to no squares at all), you'll be teaching yourself to draw freehand and perhaps to draw from your imagination as well.

The grid method is a very encouraging drawing tool, but it should primarily be used as a stepping stone to help you develop additional drawing skills. It is not recommended

that you use the grid as your primary method indefinitely.

I've noticed a trend among some artists—they are relying on the grid method alone, and are not able to draw anything without using it. They tell themselves that this is okay, because the old masters and other famous artists of yesteryear used the grid method. This is only partly true.

Many of the old masters did use the grid method. Sometimes, they used it to transfer their own smaller drawings onto a much larger (sometimes mural-sized) canvas. This was an appropriate use of the grid—murals are just so huge, it would have taken forever to try to transfer an image on them by drawing freehand!

However, these old masters drew very well without having to use grids or optical aids. They didn't rely on the grid method for everything. They didn't need to. They drew very well from their imagination and from life. They painted action poses, fantasy figures (like dragons), and self-portraits—poses that would be difficult or impossible to capture with a grid or any other pre-photographic optical aid or device. So, while these artists may have used the grid method from time to time, they also knew how to draw freehand as well. Not being able to draw freehand would have been a serious hindrance to them.

If you decide to try the grid method, I encourage you to consider it to be a useful tool that you will sometimes use. You will probably find that you will use it less often as your skills progress.

Now that you have a basic understanding of how to draw lines and see the outline and contour of things accurately, it's time to discuss shading and rendering, which are discussed in the following chapters.

## "Coloring Book" Drawings vs. Shaded Drawings

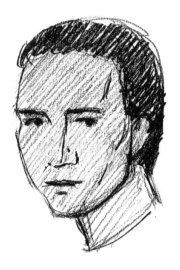 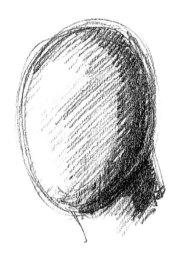 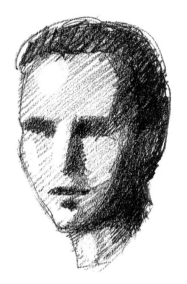

Most of us enjoyed drawing in coloring books when we were kids. We used various colors of crayon for different parts of the picture. We chose one color for a person's hair, another for their skin, their teeth, and so forth. We usually didn't try to vary how light or dark we drew with the crayon—we simply put each color in the area where it belonged.

The picture of the man on the left is drawn using a "flat" (or coloring book) style. His skin is one flat tone, his hair is a darker tone, and his features are outlined with simple lines.

The middle illustration shows an egg-shaped form with some simple shading on it. It's lighter on the left side and darker on the right side. This shading helps make the egg shape look round and three-dimensional.

The drawing on the right shows a head with the same kind of shading—lighter on one side and darker on the other. Furthermore, the features are not drawn in with simple lines, but rather areas of light and dark are used to indicate the shape of the nose, eyes, and mouth.

Which picture of the man has more of an illusion of depth and bulk—the one on the left or the one on the right?

There's nothing wrong with the flat coloring book style of art. Many wonderful artists have used it in a sophisticated, attractive way. But to get a more realistic look, using shading is the way to go.

# CHAPTER TWO

# INTRODUCTION TO SHADING AND TECHNIQUE

## Drawing and Shading the Sphere

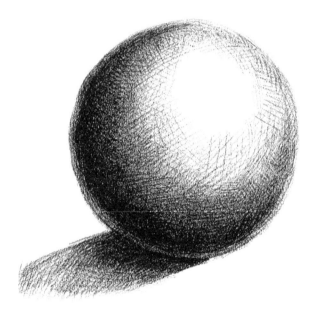

Ah, the famous sphere. It seems inevitable that every newbie drawing tutorial must show a sphere picture! Here's a sphere drawing that shows the basic shades and shadows of a three-dimensional form (the sphere).

This illustration shows how some basic grays, blacks, and whites can create depth and dimension to a picture. About five shades of gray were used. When these grays are rendered in specific areas, the sphere looks round and realistic.

Bear in mind that most black and white pictures have more than five shades of gray. But for this tutorial, it's easier to break the values in a picture down to about five basic tones.

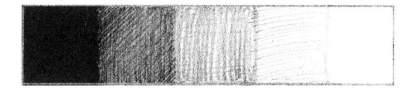

The shades of light and dark are shown here. You see on the left side that the tones go from black to dark gray, medium gray, light gray, and finally white. When you use shading in a drawing, you will be required to analyze the subject to decide which values belong where. You will also learn how to represent these grays by shading or crosshatching with your pencil or pen.

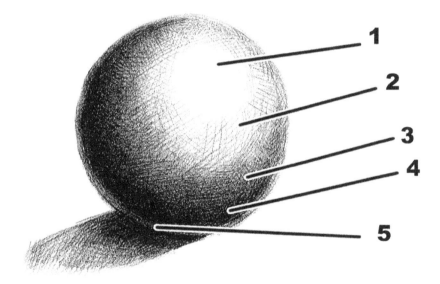

The sphere illustration with the major gray tones identified:

1. The highlighted area is usually white, or almost white. The highlight is always on the same side of the picture as the light source. The light source can be the sun, a lamp, etc. Any side of an object that is facing the light source will have highlights on it. The side of an object that is facing away from the light source will be in shadow.

2. The light gray area surrounds the highlighted area and blends the white in with the darker tones.

3.   The middle gray tone is the actual color of the sphere, without any highlighting or shadowing on it.

4.   The shadows are dark grays and blacks.

5.   The reflected light area is usually one tone lighter than the shadows. Take note of the reflected light. This is a slightly lighter rim that is often seen on the darkest shadowed part of an object (in this case, the sphere). It is there because some light bounces off of the lighter background, creating this little strip of lighter tone. (Most portraits will have this reflected light area as well.)

Just like an artist shades a sphere, they shade a portrait. The same principle applies. Practice shading spheres now, so that you will be more comfortable when you start to shade portraits later on.

**Step-by-step instructions for shading the sphere:**

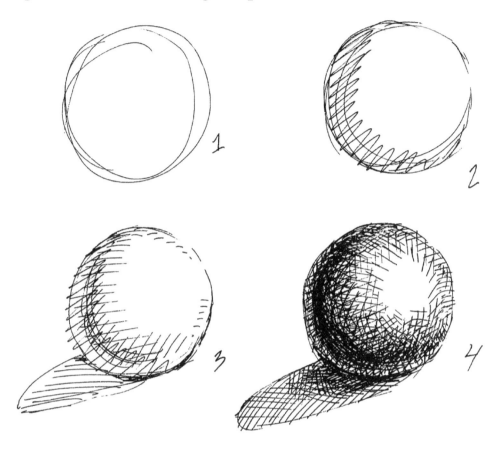

1.   Draw a circle. Easy enough, eh?

2.   Shade the left side of the circle with a medium gray. Make the shape of your shadow follow around the roundness of the sphere, as illustrated above. Don't worry about making the shadow perfect; just lay in some loose pencil strokes to indicate a medium gray tone.

3.   Draw an outline of where you think the cast shadow (the shadow on the ground) should be. Draw a darker gray shadow on the left side of the sphere (dark gray). Make this shadow smaller than the medium gray shadow that you drew in Step 2. Take care to allow for a small band of reflected light following around the outside rim of the shadowed half of the sphere. Don't let your dark gray shadow cover this reflected light area. Add some light gray tones on the highlighted portion of the sphere (right side).

4.    Finish up shading the sphere by darkening the cast shadow (making it darker where it is closer to the sphere) and adding medium grays to the sphere. Darken the darkest part of the shadowed part of the sphere to an almost-black. Use the methods described in the next tutorial ("Drawing Techniques") to render the shadows in the sphere.

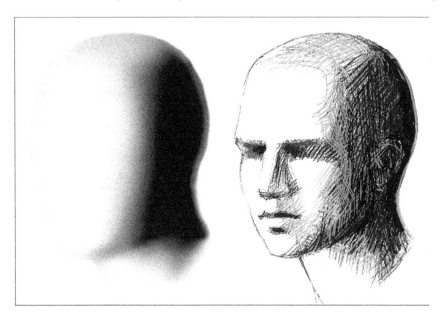

If you wonder why you should learn how to shade the boring old sphere when what you really want to do is to draw portraits, consider that the fundamentals that you will learn when shading the sphere will carry through to everything else you draw—especially the human head.

## Drawing Techniques

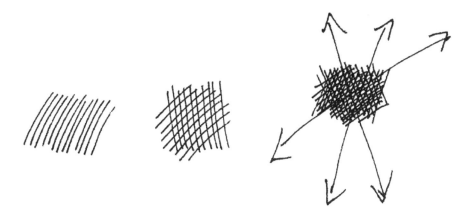

In this illustration, pen and ink is used, since many drawings in this book are also in pen and ink. However, the same crosshatching techniques can be used for pencil, charcoal, and a variety of other media. I've drawn arrows in the crosshatching example on the right, to show more clearly which direction the lines are going.

Crosshatching is a simple concept: make a series of lines going in several different directions, until the desired level of darkness is achieved. The more you draw over an area with your pencil lines, the darker that area will be. Also, the amount of space left between the lines that you draw will also change the darkness or lightness.

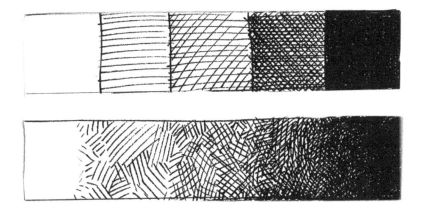

The darkness and lightness of a tone can be changed, depending on how close the lines are to each other. The closer the lines are drawn and crosshatched over each other, the darker the resulting tone will appear.

The harder you bear down with your pencil, the darker the value will be. If you barely

touch the pencil to the paper and make very delicate, careful crosshatching strokes, the value will, of course, be very light.

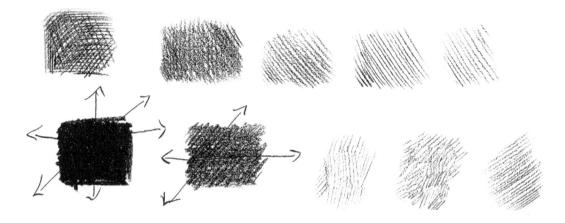

There are many variations of the crosshatching line and I encourage you to experiment and have fun practicing.

One way to start crosshatching is to make a series of lines that are about a 40-45 degree angle from each other. (See the arrows drawn over some of the crosshatching examples shown above.) If you want to get a very even tone, use a sharp pencil point and fill in any little open spots that you feel stand out too much and should have been covered by the crosshatching strokes.

One rule to always remember about pencil crosshatching: have fun! Feel free to ignore any of the general guidelines given here and go a little crazy once in a while. Try different approaches and see which gives you visually exciting results.

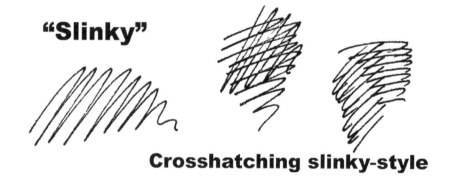

**"Slinky"**

**Crosshatching slinky-style**

Ah, yes, the slinky crosshatching style. A lot of artists use this simple rendering

technique, but I confess I got the term "slinky" (reminiscent of the childhood toy of the same name) from a wonderful book called *The Artist's Complete Guide to Figure Drawing: A Contemporary Perspective on the Classical Tradition*, by Anthony Ryder (published by Watson-Guptill). The idea behind the slinky stroke is that the line never really is broken—it's one line, going back and forth, back and forth. Crosshatching slinky style is achieved by making several slinky type lines over each other, until the desired tone is reached.

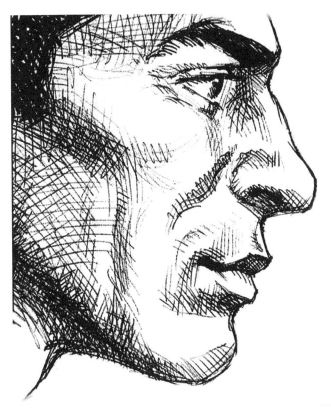

This ballpoint pen drawing has lots of slinky lines. Can you find them?

A few areas where slinky lines can be found are circled on the picture. Many slinky lines can be found all over the drawing and in most other drawings that I show here. There should also be some "contour" lines—lines that seem to follow the shape and form of the face.

In addition to crosshatching and slinky lines, the use of contour lines is recommended. Not only do they show levels of light and dark, they also can suggest the form that they are shading. Contour lines follow around the form, giving the drawing additional depth and dimension.

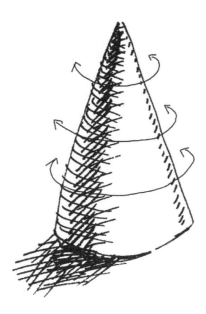

This simple cone shape has some contour lines. These lines give the cone an extra "round" look. I've added arrows to show the direction that these contour lines follow around the cone form.

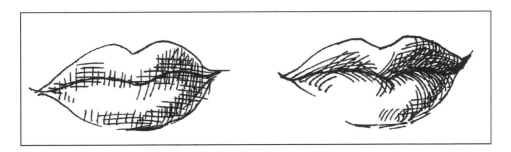

Compare the rendering on these two drawings of mouths. The crosshatching on the mouth on the left is perfectly acceptable. It indicates the shadows of the lips fairly accurately. However, look at the rendering of the lips on the right. These lips look much more lush and three-dimensional. The lines used to render the lips follow the contours of the lips, showing plumpness, where the lips dip in, curve out, and so forth.

## More pencil techniques

1. Seemingly random directions of pencil strokes can create the desired effect. There are no hard and fast rules about which direction the lines have to go. It really depends on the shape of the thing you are drawing. You can use certain pencil strokes to just lay down a tone, layer other strokes over it to help suggest the form, and so forth. Go crazy and have fun!

2. Lay down a flat tone and then use your eraser to lift up a highlight area. It's a nice effect.

3. Another variation on the contour lines notion: Using your pencil strokes to intuitively follow the direction of the shape of the thing you're drawing can really help enhance the illusion of depth.

4. Layer tones of pencil over each other. Sometimes you'll lay down a large, flat area of one tone, and then you'll add darker lines on top, to give some detail and texture.

Layer your pencil strokes, over and over, until you get an area dark enough. Build up the value. If you start to get it too dark, back off and maybe lift some of the tone up with your kneaded rubber eraser.

Pencil is a very forgiving medium. Just always keep that kneaded rubber eraser ready. Never forget that the pencil strokes you lay down can be erased later. Get a feel for the shape or outline with loose, fun pencil strokes.

## Rendering with pencil or graphite

Pencil and graphite are pretty much the same thing. Unfortunately, a lot of people like to treat pencil or graphite like charcoal—a medium that often is blended and smudged. Blending graphite has taken on great popularity in some circles, to the point where a lot of beginners are instructed to blend and are given no exposure to other techniques.

For this reason, I associate blended graphite with badly-trained beginner work. It's common to see it done poorly, with flat values and messy smudging.

Of course there are some exceptional artists who blend graphite masterfully, like Lance Richlin, author of the book *Lifelike Heads* (from Walter Foster Publishing). If you are interested in learning more about the blending technique, I encourage you to look at Richlin's work.

It seems like a lot of beginners opt to blend their pencil strokes because they don't have control over getting smooth values otherwise. Art teachers who discourage blending want the students to gain enough skill so they can get smooth, cohesive values *without* smudging. That way, the students have options—they can only use their pencil strokes to get values, they can blend, or they can use both! But, if they never learn anything other than blending, that's their only option.

In this book, I mostly work with crosshatching. When used on a smooth paper surface with small, delicate strokes, the effect is a smoothly rendered (but not messy) portrait with a lot of energy and detail. Such crosshatched drawings can look just as detailed and even photorealistic as any painstakingly blended and smeared graphite portrait. One

advantage of the detailed crosshatching technique is the use of the contour line, which adds that special suggestion of dimension. Crosshatching is also more controlled—the finished art is less apt to end up with a smudgy, untidy look.

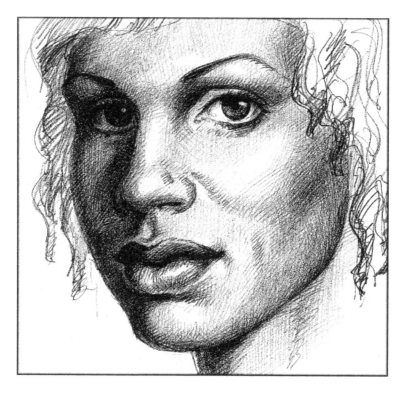

This pencil portrait of a young woman was drawn using a tight, detailed crosshatch stroke. Lighter areas of the face were drawn using a softer touch with the pencil. The pencil point was kept sharp at all times. Subtle contour lines were used in parts of the drawing to suggest roundness and form.

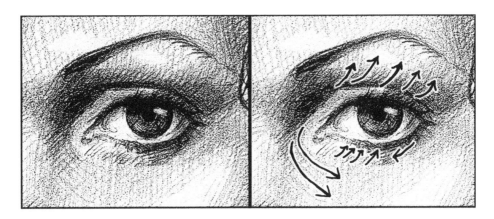

These close-ups of the eye show the individual pencil strokes. The illustration on the right has arrows showing the direction of some of the contour shading and rendering lines used in this pencil portrait. Do you see how such lines can help suggest roundness and dimension?

**Erasing mistakes**

When you draw with pencil you have the option of erasing any errors you might make in your drawing. If you merely want to lighten up or soften a small or delicate area of your drawing, knead your kneaded rubber eraser (pull and stretch it out, like putty) and manipulate part of it into a point. Use the point of the eraser to "pat pat pat" the area on your drawing that needs lightening up. You can also firmly press the eraser onto the too-dark area. By repeatedly doing this, you will lift up some of the graphite—lightening that area of your drawing—without disturbing the quality of the pencil strokes.

## Goofing off with crosshatching—Practice is fun and important!

One of the best ways to get used to crosshatching (with ink, pencil, or anything else) is to goof off and doodle. It is important to be free and loose and not always be worrying about making a "perfect" or "pretty" picture. Sometimes, just doodling with lines (or with color) will allow you to have a major breakthrough. When you relax and don't have any expectations for the drawing, the lines you draw will start to flow more easily and fluidly.

Many artists find it relaxing to do such doodles, as it helps them to create more energetic, lively work.

Notice all the different kinds of lines and marks that have been made in the previous illustration. Dots, scratches, squiggles—all these different marks may be used to indicate various textures or shadings in your other drawings.

Becoming comfortable and familiar with your drawing materials is something that is definitely recommended. Don't think that these less than serious drawings are a waste of time. They are not. For example, I remember that when I first got a mechanical pen (a technical pen that uses India ink), I could not get the hang of it. I found it to be awkward

and drawing with it was miserable. But that pen had cost a pretty penny and I hated the idea of wasting the money that was spent on it. So I kept doodling and doodling with that wretched thing. Then one day, something clicked in my brain and all of a sudden I could render very well with it. Now, the mechanical pen is one of my favorite drawing tools. All of the pen and ink drawings in this book are drawn using such a pen. So, remember that no time spent practicing drawing techniques is wasted!

## Playing around with pencil techniques—It's art, baby!

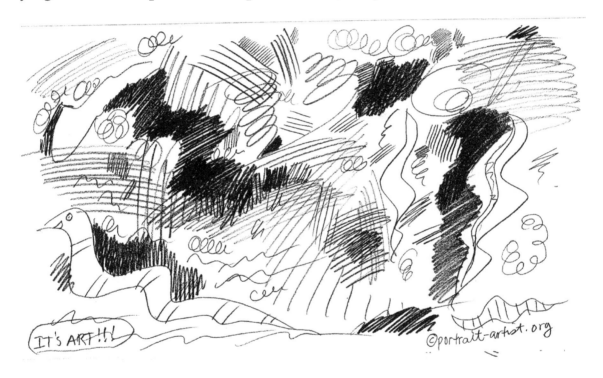

Straight from my sketchbook: another example of goofing off, this time using pencil techniques. As I hope you can tell, it isn't always required to take all your work very seriously.

Learn to relax and have fun with your practicing. It's okay to write notes, commentaries, or even little self-mocking jokes on your sketchbook drawings.

## It's okay to scribble

When you are sketching, it's okay to use a lot of searching lines and scribble lines. Keep your hand loose and move your pencil around on the paper in a searching motion—searching for the right line, the right contour, the right spot.

You'll also learn to use gesture lines. Scribble on the paper, giving a suggestion of what you want to draw. You can even draw inside the subject, using circles or sweeping lines in an attempt to capture the pose or bulk of your subject.

In the previous picture, the two drawings (or scribbles) on the left are of a person's head in profile. Notice that even though the sketch is not very detailed, the subject is immediately recognizable. The far left drawing more clearly shows the circles and scribbles that made up this simple little sketch. Loose, free lines were used and the pencil moved all over the paper, not hesitant, not lifting up from the paper too much—just searching and scribbling until finally producing something that looked like a profile.

The two drawings on the right are obviously of a cat. The middle right drawing shows the circles and sweeping lines that made up the cat shape: three circles, indicating the three sections of the cat's body, and a long sweeping line that follows the cat's spine and tail. This line is a good example of a gesture line. It was used to capture the overall pose of the cat.

Use many searching lines in your sketches to get the feel for your subject. Remember that

you can always erase any extra lines later on, if you so desire.

## Final Thoughts on Beginning Drawing:

While I have certainly attempted to cover the basics of drawing in this section of the book, you are encouraged to continue to study general drawing techniques. I recommend *The New Drawing on the Right Side of the Brain*, by Betty Edwards, and *Keys to Drawing*, by Bert Dodson. Both are excellent books and suitable for any artist, particularly the beginner artist.

# SECTION TWO: FUNDAMENTALS OF DRAWING THE HEAD

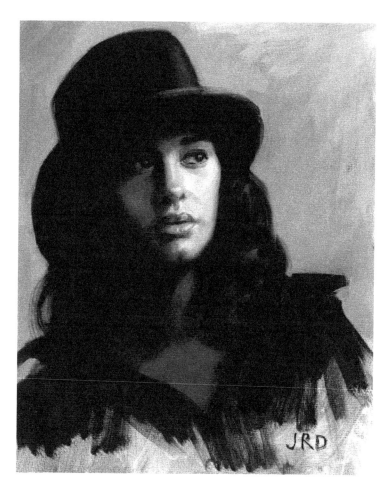

*"Black Hat," oil on panel. © JR Dunster. Based on a photo by Cathleen Tarawhiti of DeviantArt.com.*

# CHAPTER THREE

# DRAWING THE FACE: BASICS OF HEAD STRUCTURE AND ALIGNMENT OF FEATURES

## Drawing the Face: Basics of Head Structure and Alignment of Features

Here's a drawing that I like to call "blockhead." I made this to show you that the head has structure, just like a box or a block.

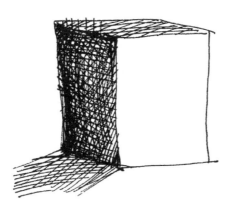

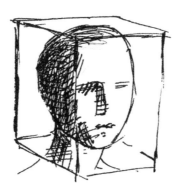

One way to visualize the structure of the head is to think of it as being in a box. The head,

like a box, has several distinct planes. Even though the head is somewhat egg-shaped, it also has a definite side, front, and top.

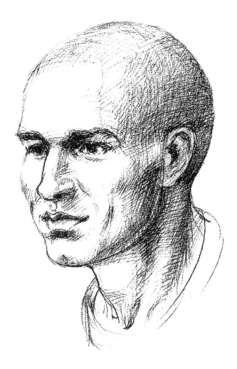

Here's the "Happy Bald Guy." I use this drawing on my Website and I wanted to make sure to include him in this book. He seems so happy, after all!

This drawing has a purpose, though—I'm using it to show you the basic egg shape of the human head and also to show you that the head has three dimensions—that it is round.

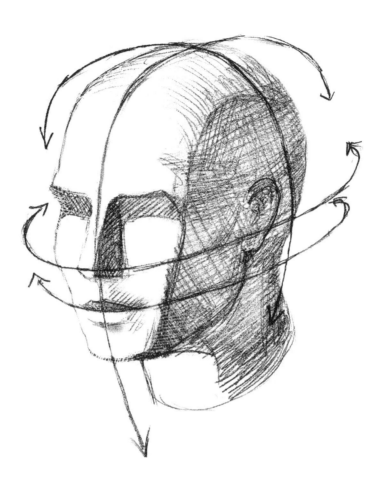

The planes of the head are more clearly illustrated here. The arrows indicate the roundness of the skull.

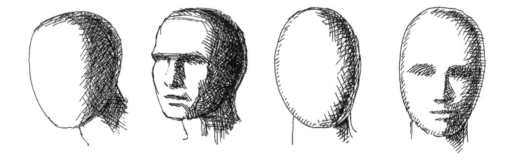

The two left head shapes in the illustration above show the head in three-quarters view, where you can see a definite front and side plane of the head. The front view of the head (the two right head shapes in the illustration) shows a more egg-shaped view.

It is most important for you to understand that the head is a three-dimensional thing, with bulk and shape. Keep the egg-shaped and blockhead concepts in mind as you continue to observe and draw faces. Another useful method is to feel your own head and notice where its top, side, and front are.

## Alignment of the features of the head

Now that we have covered the general structure and planes of the head, it's time to illustrate the placement and alignment of the features of the head.

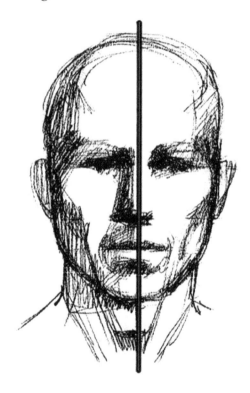

The vertical line divides the face into two separate halves. Use this to keep each side of the face even and balanced.

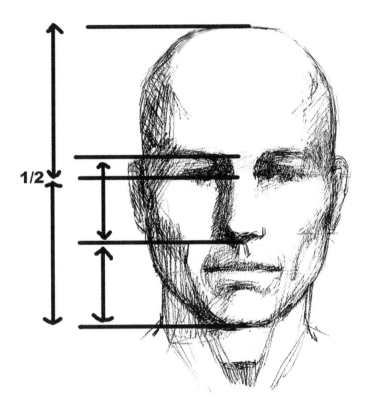

Notice the line that goes across the eye-line. The eye-line is right in the middle—between the top of the head and the bottom of the chin. The illustration has this line marked as a halfway point.

You will also see a line at the eyebrows, one at the nose, and one at the bottom of the chin. This shows you that the nose is centrally located between the eyebrow line and the bottom of the chin. Obviously, some people will have longer or shorter noses, longer or shorter chins, and so forth, but this rule is a good starting point. Be sure to observe these measurements in the person you want to draw.

A little less than halfway down from the nose-line to the bottom of the chin is where the mouth is positioned. In the illustration I show here, the face has an average to long chin— but not everyone has the same kind of chin. On people with smaller chins, the mouth might be closer to midway from the tip of the nose to the bottom of the head.

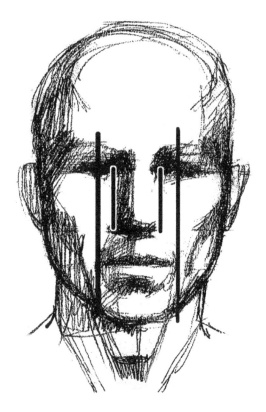

Two more interesting areas of alignment of the face: the corner of the mouth lines up approximately with the middle (pupil) of the eye and the outside of the nose (outer edge of the nostrils) lines up with the inner corners of the eyes.

See how everything lines up quite nicely! As long as you remember to use these alignment rules you are way ahead of the game. You will have much less trial and error in your portrait drawing.

In starting a portrait drawing, it's always a good idea to "block out" the features, starting with these alignment lines. Draw these lines in faintly so they can be erased later.

**Using the width of the eye as a form of measurement**

Yes, this is a peculiar-looking illustration. But there's a reason behind it. I want to show you how to measure the proportions of the face to make sure you're getting everything right.

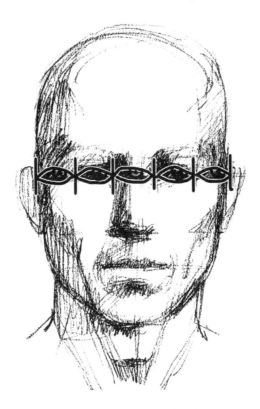

The line of bizarre almond shapes going across the face represents "eye-widths." Each creepy almond shape represents the width of one of the eyes on the face. The black lines are there to make the divisions between eye-widths more obvious.

You will notice that there is an eye-width between the two eyes. There is close to another eye-width between the outside edges of the eyes and the edge of the head. So this means that the face is almost five eye-widths across.

It's a good idea to use this eye-widths trick continuously when drawing the face. It helps you keep the proportions right in every area of the face and head. The simplest way to use the eye-widths trick when copying a photo is to take a piece of paper, mark off the width of one of the eyes on the photo, and then mark the width of the eye on your drawing. Measure how many eye-widths the source photo has in various areas. Confirm that your drawing has the exact same eye-widths. (For instance, if the source photo tells you that the model has one eye-width between the eyes, your drawing should have the same proportions.)

Use the eye-widths technique to make sure you've made the forehead high enough, to

confirm that you've got the chin small (or big) enough, to verify that the space between the nose and the mouth is accurate, and so forth. Double-check everything just to make sure. You might be amazed at how frequently your proportions will go astray. Your drawing may look acceptable to you, but a quick check with the eye-widths technique will confirm that you got something dramatically off. Don't feel bad; we all get proportions off, especially when we are starting out!

The eye-widths technique is best used while your drawing is still in its preliminary stages. It is always much easier to make erasures and adjustments then.

This is a really fantastic measuring technique and it will help you understand how to keep the proportions of the face accurate and correct. It will also help you see where you are prone to distort the face. (For instance, you might notice that you always make the forehead too low, or the chin too long.) When you are aware of where your weak areas are in your drawings, you will be able to improve and correct these weaknesses all that much quicker.

**Tips for drawing the head from three-quarters view**

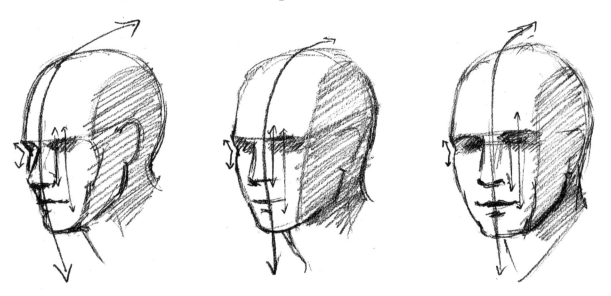

The arrowed line in each of these heads is going down the middle of the head—right

between the eyes and at the center of the nose, mouth, and chin. As the head turns farther away from front view, this center line will start to get closer and closer to the edge of the head.

Even when seen at different angles, the inner corner of the eye will still line up with the outer nostril. The middle (pupil) of the eye lines up with the outer corner of the mouth.

The angle of the nose will also become more pronounced as the head turns. The tip of the nose may even start to go past the edge of the face (as seen in the drawing on the left).

The double arrows at the brow area of each of these faces show that as the face turns more toward the side, the ridge of the brow-line becomes more pronounced.

**Different shapes of heads**

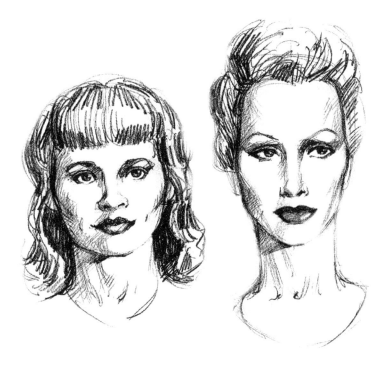

Do you notice the difference between these two young women? The woman on the left has a rounder head. The woman on the right has a long narrow head. Now compare their

necks: the woman on the right has a shorter neck—one that looks more normal and natural with her shape of head—while the woman on the right has a long, slender neck.

Different people have different-shaped heads and bodies. Identify the head type of the person you are drawing. Is it long and narrow, heart-shaped, oval, round, or square?

# CHAPTER FOUR

# DRAWING THE PROFILE

There's a different dynamic going on when you are drawing profiles. You look at the edges and contours of the face in a completely different way than when you do when you draw a front-view portrait.

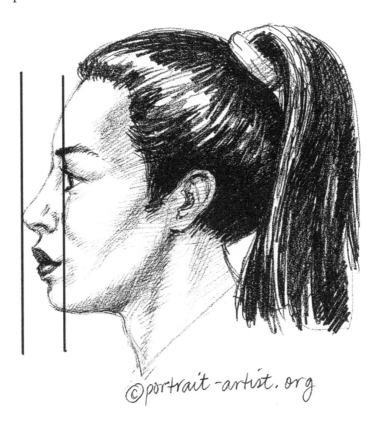

©portrait-artist.org

Notice the two vertical lines: one at the tip of the nose, and one that lines up with the outer edge of the mouth and the front of the eye. Look at the distance between these two

lines—there's quite a distance, isn't there? Keep this distance in mind when drawing profiles. Too often new artists draw the profile too flat, so that the eyes are not recessed enough, and the nose does not stick out enough. Try to avoid this typical beginner pitfall!

See how the eye is not flush with the edge of the face. Notice how much room is given to the bridge of the nose. The eyes are set in, or recessed. Also notice that vertically, the front of the eye usually lines up with the outer edge of the mouth.

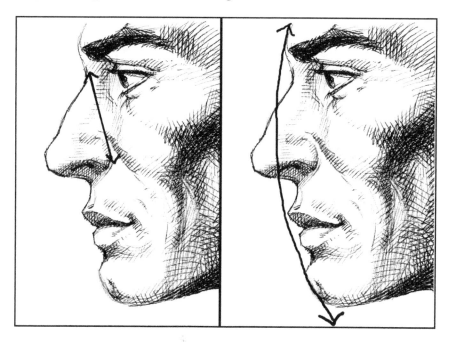

This illustration (of two profile drawings of a man) shows how the nose sticks out prominently from the plane of the face. On this particular face, there is a general curve— it is not a straight up-and-down profile. Many people have some degree of a curve to their profiles, starting from the bottom of the chin and going up to the hairline. Of course, sometimes you will encounter a person with an almost straight up-and-down profile.

The lower lip doesn't come out as much as the upper lip. Notice that the chin and "muzzle" area (mouth and chin) recede, just a little. Even when the portrait is of someone with a strong chin and jaw, usually the chin and mouth area do not jut out as much as you might assume. They are gently receding—just a *little* bit.

There will always be that occasional person who has a chin that juts out more noticeably,

or a lower lip that comes out farther than the upper lip. That's the fascinating thing about faces—for every rule there's an exception. Because there are always going to be exceptions to the rules, you should be highly motivated to really look at your model to see how their individual features line up.

Note that the faces here don't have what would be considered to be an especially large nose. And yet, the nose does stick out to some degree.

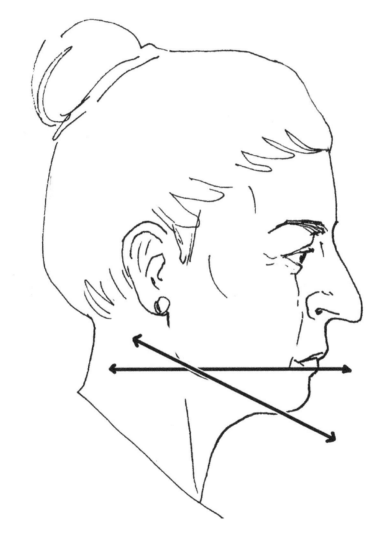

This drawing shows how the mouth lines up with the jaw-line (at the spot where the jaw starts to curve up toward the ear). Also notice the basic angle of the jaw and how it tilts up toward the ear. Each person's features may line up a little differently, so take care to be observant and look for their unique proportions.

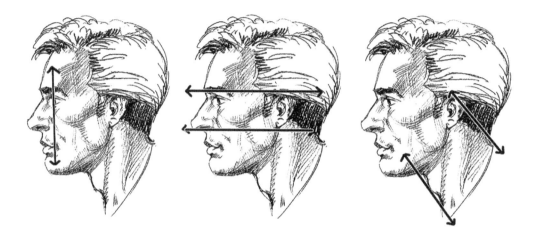

In the profile (on the left) in this illustration, notice where the front of the eye lines up with the outside of the mouth. The center illustration shows where the top of the eyebrow lines up with the top of the ear, and how the bottom of the nose lines up with the bottom of the ear. This is where the ear is to be placed—between the eye-line and the bottom of the nose. The profile drawing on the right shows how the neck is tilted back—it's not straight up and down. Make note of where the neck connects to the head—it's not too far back.

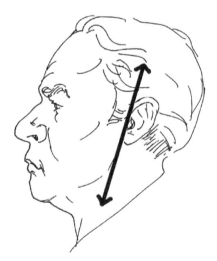

In profile, you can see that the ear is tipped back at a slight slant.

These interesting alignment lines are what help us keep the face in proportion and are also a key component of capturing a good likeness of the person we are drawing.

It takes a little while to remember all these individual measurements. The more you practice, the easier it will become for you to see these proportional relationships between the various "landmarks" of the face and head.

## Remembering that there is a brain in that skull

This is probably one of the most commonplace problems for new portrait artists—not giving the head enough room in back. People get so focused on the front of the head—where all the features are—that they forget that there is a brain in the back of the head and that this brain needs room!

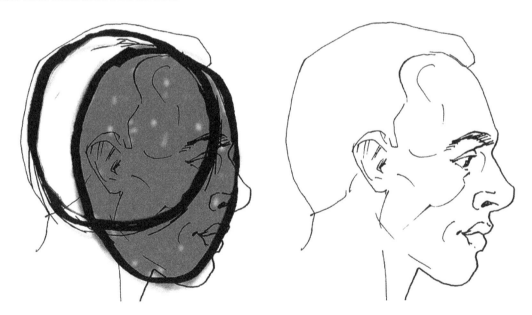

One classic way to start to draw a profile is to draw an oval (or egg shape) for the front of the head, and then draw a circle (a completely round circle) at the back. You can see an example of this in the illustration to the left. Getting that circle round and big enough to make room for the brain is important. Don't neglect this detail, or you'll be drawing people with flat heads.

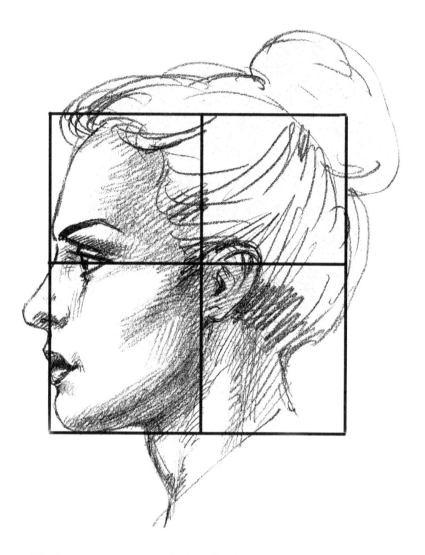

If you put the profile into a square and divide the square into fourths, you will see that the eye is aligned with the horizontal line that goes across the middle of the square. The beginning of the ear is aligned with the vertical line that divides the square into two halves.

You will notice in the profile that the eye is shaped somewhat like an irregular triangle. A common beginner mistake is to make the eye an almond shape (like it is seen from the front view) and to place the eye flush with the edge of the bridge of the nose. But that is not correct. The eye is set in. Think of the term "deep set eyes."

The triangle shape of the eye when seen in profile

## Step-by-step profile

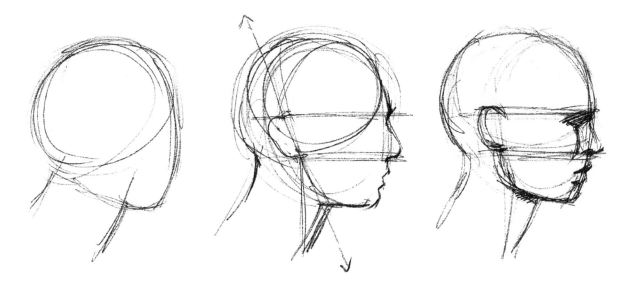

1.  Draw the oval and the circle to block out the profile (as described and illustrated earlier in this tutorial). Draw two lines indicating the neck. Make sure that you draw the neck at an angle.

2.  Draw alignment lines from the top of the eye and the bottom of the nose so you can

get the proper placement of the ear. Draw the alignment line to get the proper angle of the ear and jaw.

3.    Block out the basic shading areas of the features and structure of the face.

4.    Lighten up and erase some of the alignment lines. Start to indicate the details of the features. Indicate the shape and style of the hair.

5.    Add final details to the face. Erase any remaining alignment lines.

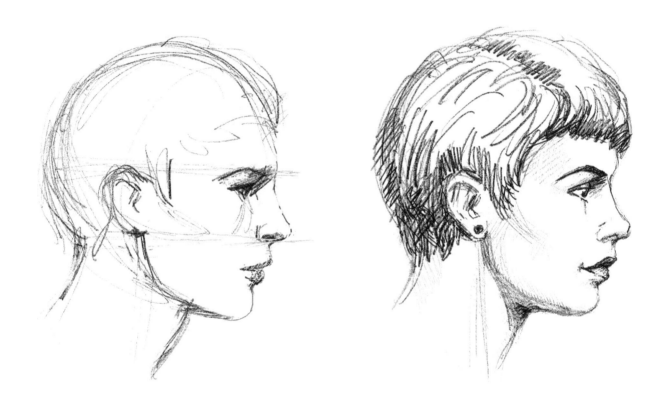

*Step-by-step profile, steps 4 and 5*

# CHAPTER FIVE

# THE FEATURES AND HAIR

Now that we've covered the general structure of the head and placement of the features, it's time to look at each feature in more detail.

## Drawing the Eyes

The eyes are a main focal point of the face. When you draw the eyes well (or if you make mistakes) they will be sure to be noticed right away.

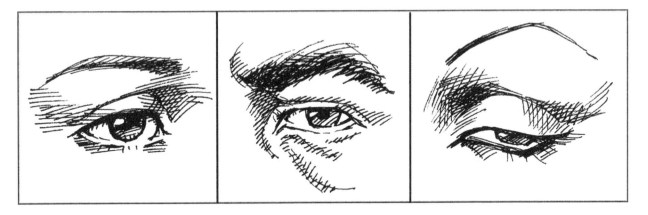

*A few examples of different kinds of eyes*

The human eye has a lot of variations, so close and careful observation is always needed to capture the specific characteristics. Here we're going to cover some generalities and a few rules about the eye.

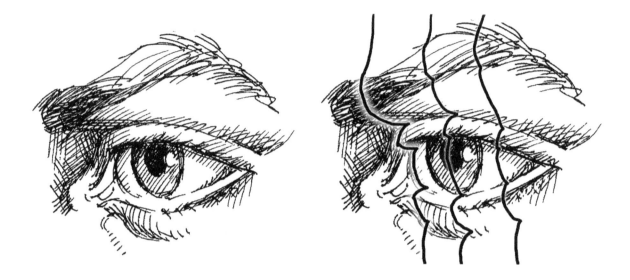

Understanding the dimensions of the eye is important. In the illustration on the right, some contour lines have been drawn over the eyebrow, eyelid, and eye.

As you can see, the eye is set in from the forehead, starting with the eyebrow. The upper lid comes out a bit and then dips in to allow for the thickness of the upper eyelid.

The contour lines go around the roundness of the eyeball. This contour then follows the thickness of the edge of the lower lid.

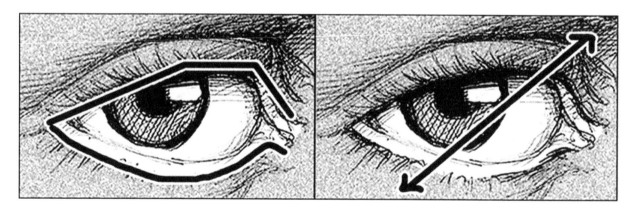

The above illustrations are more than a little bizarre, but they do show some important aspects of the eye. The outline on the left illustrates the eye's basic almond shape. The eye on the right shows an arrowed line going through at an angle. This line shows that there is an angle to the shape of the eye. The top of the eye has its widest point to the right and

the bottom of the eye has its widest point more toward the center or left. The arrowed line is going through the widest areas of the upper and lower parts of the eye, to show this angle.

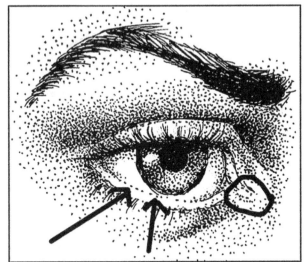

The thickness of the lower eyelid (arrows point to it in the eye on the left) is something that should not be overlooked. You can also see a little bit of the upper eyelid thickness in this particular eye as well (inner corner of the eye).

Be sure not to overdo the rendering of the thickness of the eyelid. It isn't necessary to make a harsh line across the whole border of the lower eyelid. Use subtle or soft lines to suggest this thickness. Drawing harsh lines on this part of the eyelid will make your subject look like they have red or dry eyes.

The tear duct is circled on the eye illustration on the left. It will be very noticeable if you don't draw the tear duct. Just like with the eyelid thickness, you should be subtle and use soft lines to suggest it—no need to draw it in great detail.

## The pupil and the iris of the eye

Now we get to one of the most important details of the face, and something that is too often overlooked: the iris and pupil of the eye. A common error for new artists to make is to draw the iris or pupil as not truly round. Even when a portion of the iris is obscured

by the eyelid, it does not mean that it shouldn't still keep its round shape.

Rarely do you see the entire *roundness* of the iris. Ordinarily the top of the eyelid will cover part of the iris and sometimes the bottom lid will cover it as well. If you try to show all or most of the iris, the eyes will have an alarmed look—something not usually seen in a portrait.

It cannot be emphasized too much about making the iris and pupil round. *They should be round*. Not sorta round, not almost round—they should be <u>round</u>. Absolute roundness is required when it comes to drawing the iris and pupil. Some artists even use little plastic templates with circles of various sizes. These templates help draw the iris and pupil completely and utterly *round*.

Not only should the pupil and iris both be round, they should be concentric. The pupil should be exactly centered in the middle of the iris—not off center or off kilter—not even a little bit.

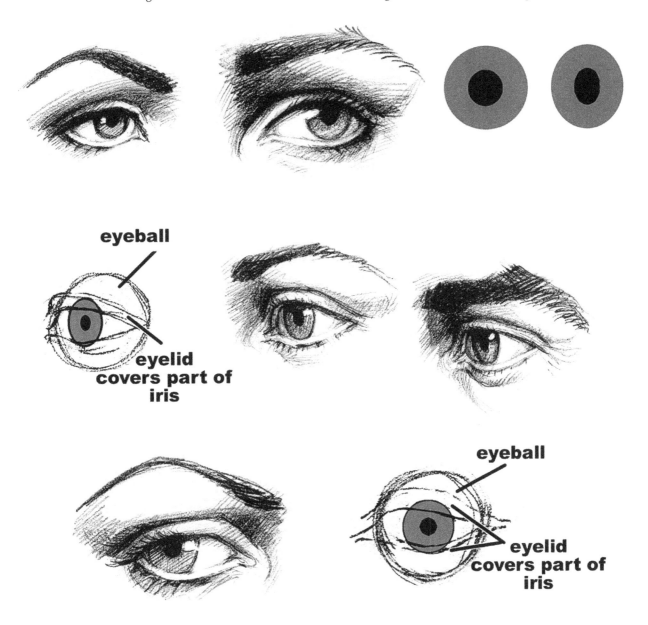

eyeball

eyelid covers part of iris

eyeball

eyelid covers part of iris

When the person in your portrait is being drawn from a three-quarters view or they are looking off to the side, the iris and pupil no longer are completely round; they will become oval shaped. The above illustration (affectionately entitled "Lotsa Eyes") shows the shape of the iris and pupil from a front view and from approximately a three-quarters angle. The more extreme the angle, the more oval the pupil and iris become. However, the pupil always remains perfectly centered within the iris.

Here is a simple formula for the shading of the eye and iris. (There are always exceptions to any formula, of course, so be observant and look for possible differences in each individual you are drawing.)

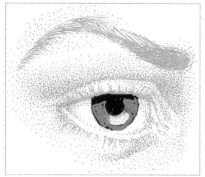 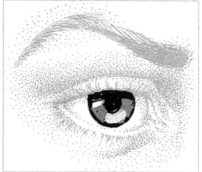 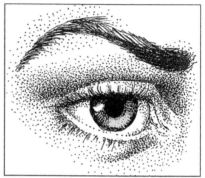

1.    Draw a darkened area (seen in the illustration to left) covering most of the iris. Make the pupil completely black (and round—don't forget that it should be round!) and draw a dark shadow on the top of the iris, right under the upper eyelid. The thickness of the upper eyelid casting a shadow on the iris gives the eye an especially realistic look.

2.    Draw a highlight on one side of the iris (as seen in the center illustration). Or, if you are drawing in pencil or ink, leave this area open in step one, to allow for the highlight. The highlight will be placed on either side of the eye, depending on the position of the light source. Always place the highlight on the same side of the eye as the light source. Don't place the highlight on the shadowed side of the eye. (For instance, if the left side of the face is more in shadow and the right side is facing the light source, place the highlight of the eye on the right side.)  An optional step would be to draw a dark border or rim around the bottom outside of the iris. Most people's irises have a darker border or rim.

3.    Sharpen and refine the detail of the iris and pupil and if you like, add a suggestion of the little iris lines. Do not overdo these striations or lines, or else the iris will look like a wagon wheel with little spokes coming out of the pupil. The "wagon wheel spokes" look is, unfortunately, a very common mistake in some beginner portrait art.

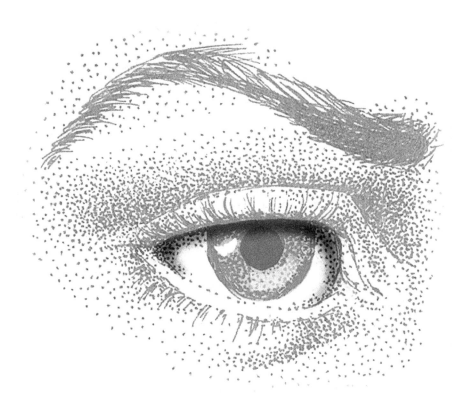

Another thing that you must not forget to do is shade the eyeball itself. As you already know, the eyelid has some thickness. The thickness of the upper eyelid will cast a shadow on the top of the eyeball. Also, the eyeball itself is round, like a sphere. So a shadow is needed to suggest the eyeball's roundness.

The corners of the eye will also be more in shadow. Make the shadow subtle and soft (as seen in the shadowing in the illustration above).

If you don't add this shadow to the eyeball (but rather leave the whites of the eyes completely white) the eye will not look natural. When working on a color portrait, remember that the white of the eye isn't really white. It is usually a very pale peach, or pale grayish-peach. The highlight of the eye is often a little lighter than the whites of the eye—but it often isn't a pure white either.

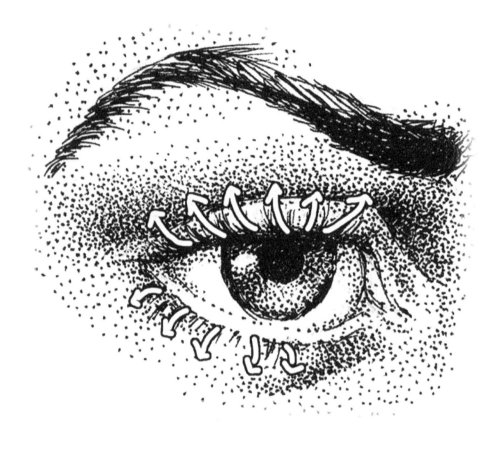

*Illustration showing the direction that eyelashes grow from the eyelid*

Rendering eyelashes is another detail that is often done incorrectly. The simple fact is, you don't need to overdo eyelashes. Make them feather out and just suggest them on the lower lid. Draw a few eyelashes but don't try to draw every single itty-bitty eyelash—it never ever looks right. If you overdo the eyelashes, you'll soon get the tarantula look.

It is even possible to not draw that many eyelashes at all—just draw a modified eyeliner look; this can often pass as eyelashes.

The highlights of the eye and eyebrow are shown in the above illustrations. The eyebrow is placed on the ridge of the brow. Therefore, the ridge of the brow and the eyebrow sometimes will have a highlight on them (illustrated above). The illustration on the right shows the direction that the hairs of the eyebrow grow.

 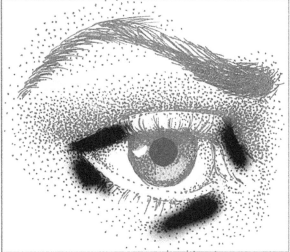

The eye on the left shows some areas on the upper eye that are typically in shadow. Since the eye is set in, the brow area (above the upper eyelid) is usually away from the light source and will have some shading on it. (Of course, with different lighting settings, the shadows on the entire face can change.) The eye illustration on the right shows that the outer areas of the eyelid usually have more shadow.

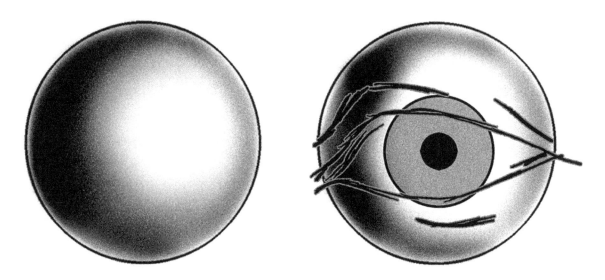

You learned how to shade the sphere earlier in this book. Well, the eyelid is wrapped around a sphere (the eyeball). Therefore, it will receive some of the same kind of shading that a sphere (ball) will. The outer edges of the eye (and eyelid) will be more in shadow, while the center part of the eye (and eyelid) will be lighter.

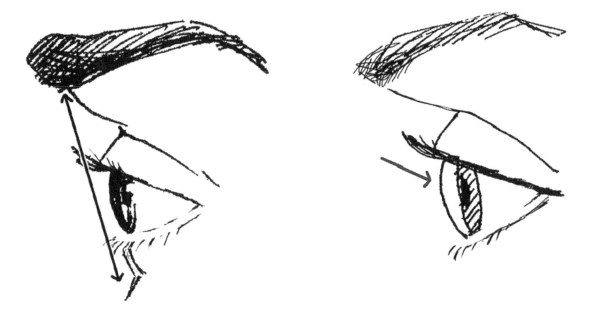

The eye from profile has a modified triangle look (as further described in the chapter on drawing the profile).

The eye is set in at an angle (as the arrow shows on the illustration on the left).

When seen in profile, the iris and pupil are now an extreme oval shape. The cornea of the eye is actually transparent, while the colored iris and pupil are more flat and disk-like in shape. Look at someone's eyes from the side to identify this clear cornea. Notice the flatness of the iris and pupil.

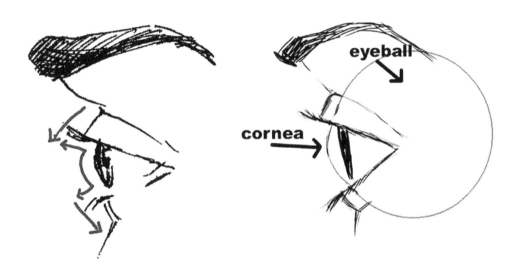

On the drawing on the right, the arrows point to the overall contour of the eye and eyelid as seen in profile. See how this line dips in and out to allow for the thickness of the eyelids—for both the top and bottom eyelids. Once again notice how the eyeball is rounded. The illustration on the right further shows the roundness of the eyeball.

## Understanding the brow area

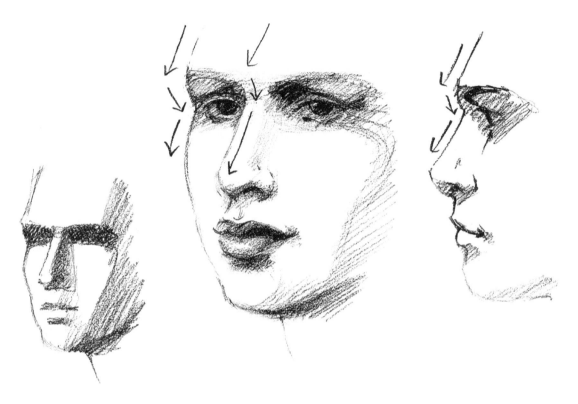

The lighting in the above sketch exaggerates the shadow over the brow and eyes. It helps illustrate the concept that the brow (and eye) is set in from the plane of the face. Some people will have less deep-set eyes than others, but all people's eyes are set in at least a little. In some lighting situations you will suggest the brow with light shading; other times the shading over the brow will be quite dramatic.

Feel your own face and brow to further understand how the eyes are placed in the skull.

## The eye as seen from three-quarters view

The eye takes on an unusual shape when seen in three-quarters view. The inner corner of the round iris shape is obscured by the edge of the nose and brow. From this view, it is easy to see how the thickness of the eyelid is wrapping around the roundness of the eyeball.

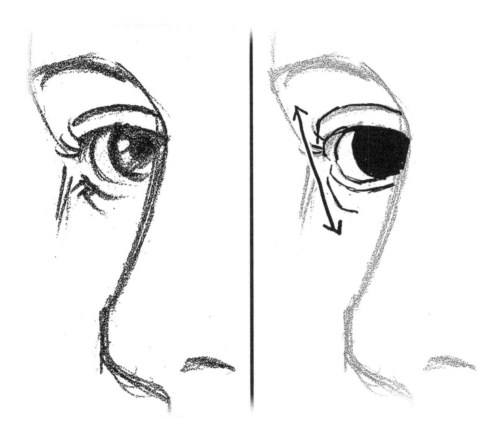

The arrow on this illustration shows that even when seen at this angle, the upper eyelid tilts out more than the lower lid.

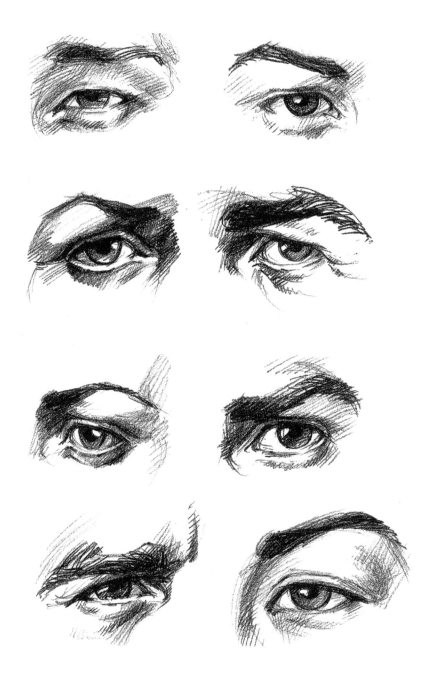

## Page of eyes

The human eye comes in so many beautiful variations! Notice the vast differences in eyelids—some eyes are deep set (have a dark shadow in the inner corner) while other eyes (usually Asian eyes) are set more shallowly. Eyebrows also have many fascinating differences—some are arched, some bushy, some faint.

## Drawing the Nose

If you find drawing the nose to be perplexing, you are not the only one. It isn't so difficult once the fundamental structure of the nose is understood.

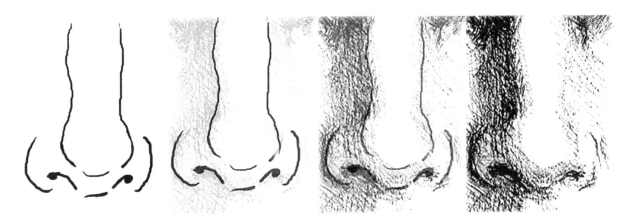

Above are four nose illustrations. The drawing on the left shows the simple outline of the nose—two lines for the length of the nose, the round ball at the tip, and the nostrils. The nose is made up of these simple shapes.

The two center illustrations show the basic outline of the nose, with some shadow and rendering starting to show.

The illustration on the right shows a completely rendered nose. Notice how the strong outline on the light side (facing the light source) is almost gone. See how the outlines for the nose are now indicated more with shadow, rather than harsh lines.

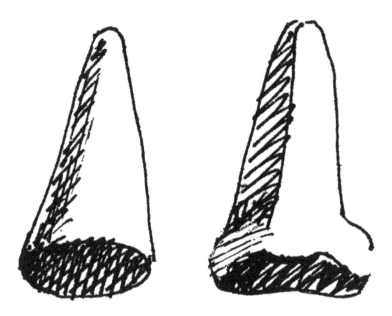

Start out by thinking of the nose as a modified cone shape. As with a cone, the shadow will often fall on one side more than the other. Like a cone, the underside will have more shadow. The side of the cone that is facing the light source will have much less shadow.

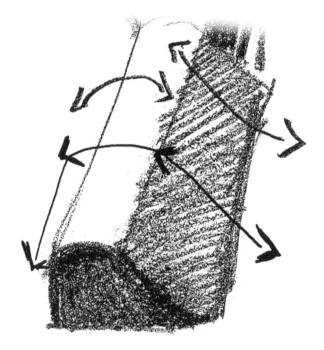

If you look at the nose from an angle, you will start to see that it also has a definite wedge

shape, with two sides and a top. Once again, notice that the underside of the wedge (where the nostrils are) usually has more of a shadow.

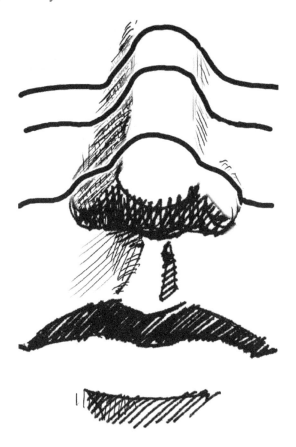

This illustration shows the shape of the nose by the use of contour lines.

The nose and mouth are connected by a groove (called the *philtrum*) that runs from the bottom of the center of the nose to the top of the lips. Be careful when drawing this groove. Usually just some shading is all that is needed—no hard or defined lines.

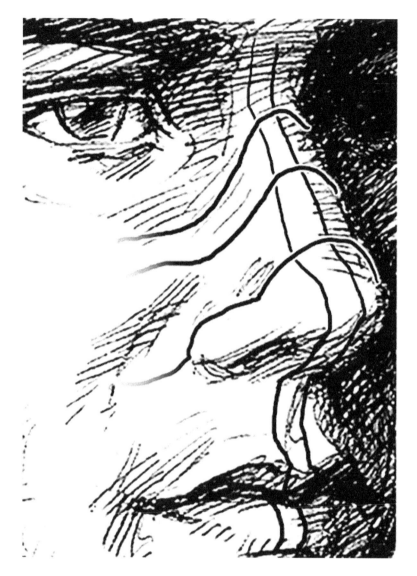

This illustration shows the contours of the nose (and also the philtrum and mouth) as seen from three-quarters view.

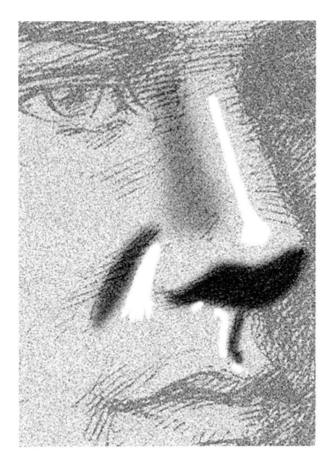

Here some of the more delicate highlights and shadows of the nose are emphasized. The line that comes from the top of the nostril down to the edge of the mouth (the smile line) must be rendered with a sensitive and delicate touch. On many people it will only be a shadow, not actually a line. This shadow may not go all the way down to the edge of the mouth. It may softly fade at about halfway down.

Some people have a more definite line between their noses and their mouths, but even these lines should not be drawn too harshly. Again, they should be rendered with mostly shadows. Too often, newbie artists give their portraits "Howdy Doody" smile lines when they are not needed.

There is often a highlight between the outer edge of the nostril and the smile line. You don't always have to put the start of the smile line right smack up against the nostril. On some people, there is this little space between the smile line and the edge of the nostril. Look for it when you are drawing around the nose.

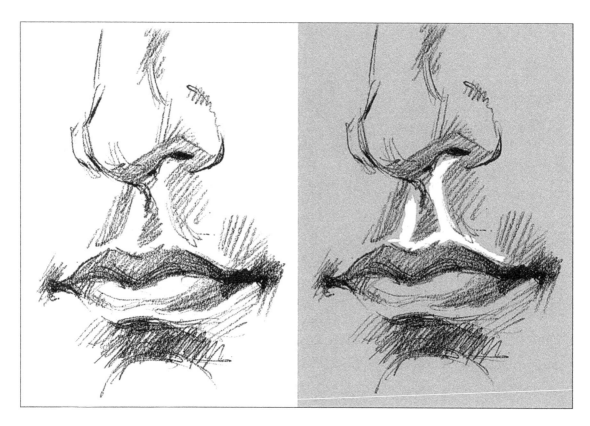

The nose and the mouth are connected by the upper lip and philtrum. The highlighted area on the picture on the right shows how the ridge surrounding the philtrum follows its way all the way up to the bottom of the nostril—often in the form of a highlight.

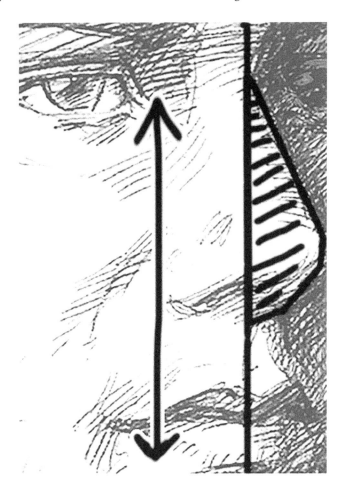

Drawing the nose from a three-quarters view can be a little puzzling. The nose is seen at an angle and getting this angle correct is difficult.

A vertical line has been drawn down the center of the face. The oh-so-flattering lines on the right (shadowed) side of the nose show how much of the nose is on the right side of the center line. The nose sticks out or is at an angle. When the face is seen at three-quarters view, for instance, you have to draw the nose at an angle too.

The arrowed line shows that the edge of the nostril is aligned straight down from the edge of the inside of the eye. This line also follows down to show you what portion of the mouth lines up with the nostril and edge of the eye.

The man in the drawing does not have an extremely wide or large nose and yet there is some definite width to it. A common mistake is to make the nostrils and nose way too narrow. Take special care to get the width of the nose correct.

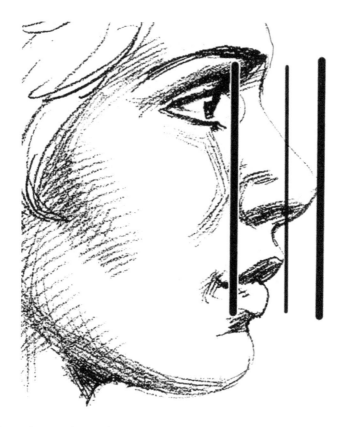

The above illustration shows how far the nose sticks out from the plane of the face. Don't be afraid to make the nose stick out. There will always be variations in nose size, but remember not to be too timid with the nose—take care not to draw it too flat or small.

These rules for the nose will always have exceptions. Some people have larger or smaller noses. Some people have very wide nostrils while others have narrower nostrils. No matter what the length or size of the nose, however, it should be shaded and rendered with sensitivity and care. It can't be repeated enough: avoid outlining of the nose—most of it can be rendered with shading.

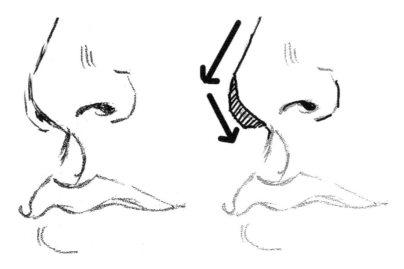

When the nose is seen at the three-quarters view, the nostril on the farther side of the head is partially obscured.

## The nose, step by step

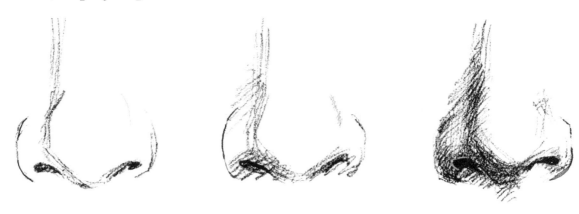

1. First, sketch out the outline of the nose. You shouldn't have to draw dark lines down both sides of the nose. Usually one side is more shadowed than the other.

2. Start to add a little shading to the side of the nose that is in shadow and the bottom of the nose. Define the nostrils. Shade the side of the nostril that is on the shadowed side of the face, but don't necessarily shade it as much as the rest of the face in shadow. The nostril is round and therefore it might attract a little more light.

3.   Finish shading the nose. Suggest, through gentle rendering, the roundness of the center (bulb) of the nose and the roundness of the nostrils.

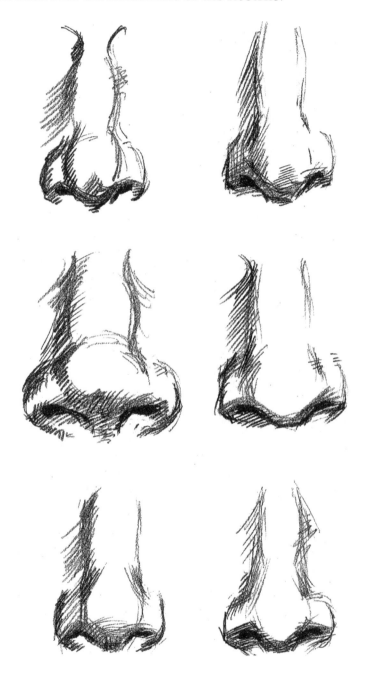

**Page of noses**

Noses come in a variety of shapes and sizes. Some are tipped up; some are broad and

some are narrow; nostrils can be narrow or flared out. The bridge of the nose comes in many different shapes as well—some are wide and bumpy, others are narrow and straight.

## Drawing the Mouth

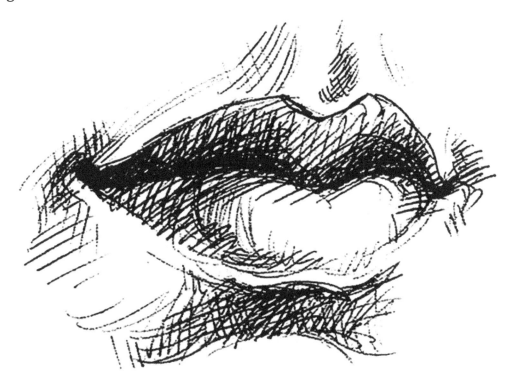

The mouth and lips are a fascinating part of the face. Mouths can be very diverse in shape and size (extremely full or extremely thin), so careful observation is always recommended when drawing each individual's mouth.

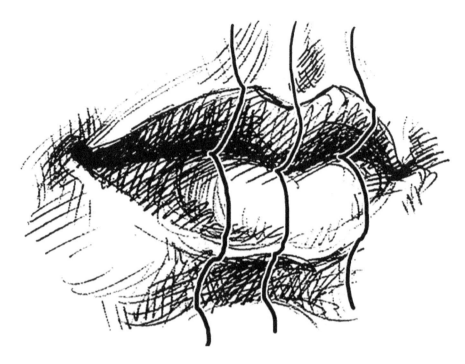

Here some contour lines have been drawn over the mouth. The upper lip dips in (and therefore usually is darker, since it is more in shadow). The lower lip comes out and is lighter (it's usually facing the light source). The corners of the mouth typically have more shadow.

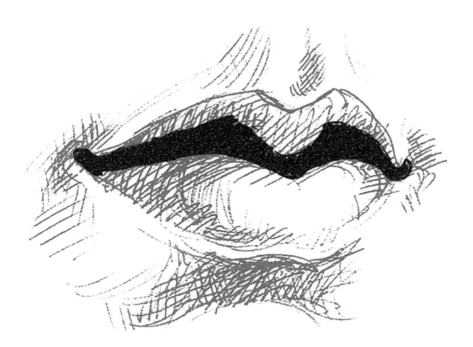

The dark area in the drawing above shows a particular shadowed area of the upper lip. With most lighting situations (when the light source is not coming from underneath the model), the upper lip will be darker than the lower lip. The area defined in the drawing above can be particularly dark. This is the area where the lips really start to curve in to the inside of the mouth. This shadow's shape is defined by the sections of the lips that are shown in the next illustration.

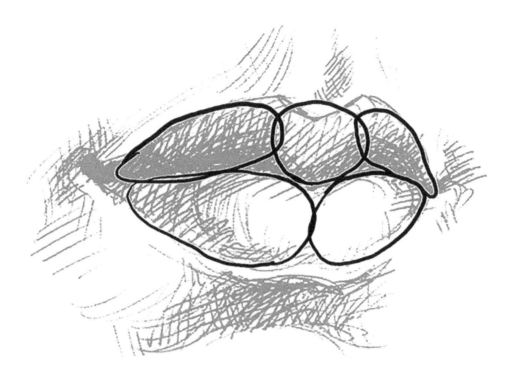

In this picture you can see that there are five basic sections of the lips. Depending on how much of a Cupid's bow the person has, you will emphasize these sections more or less. When you draw the mouth, be looking for these subtle (or not so subtle) sections of the lips.

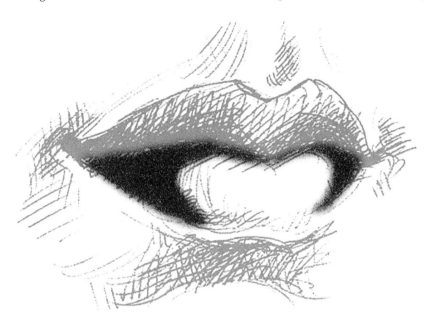

The bottom lip also has a specific area of shading to it. The darkened area in the illustration shows a portion of the lower lip that usually has more shadow. The closer to the edges of the mouth, the darker (or more in shadow) the bottom lip gets. But remember—the bottom lip is usually lighter than the top lip because it is facing upward, toward the light source.

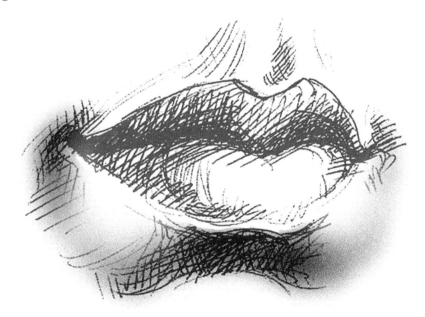

The darkened area in this picture shows an area around the mouth that sometimes can be in shadow or partially in shadow. The mouth isn't just plopped onto the face; it is a

three-dimensional thing with surrounding muscles and structure. With most people there will be some shading (subtle, but there) under the lower lip, and around the corners of the mouth.

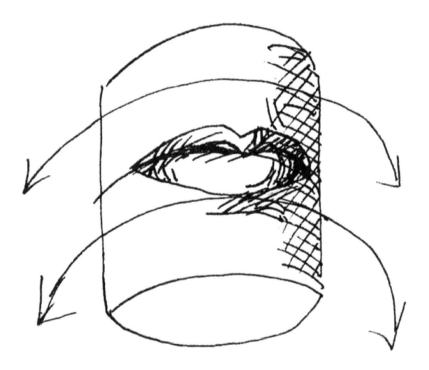

This somewhat unusual-looking illustration shows that the mouth is wrapped around the skull. Feel your own mouth and you will notice that it does go around your teeth and is not on a flat plane on the front of your face.

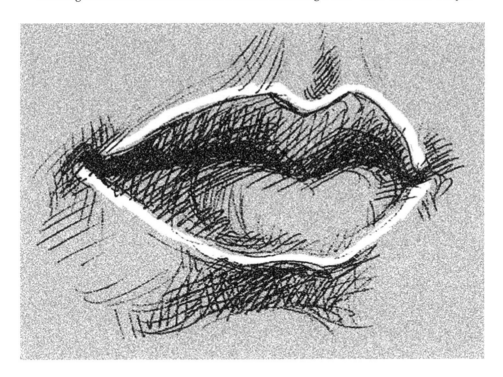

The highlighted area all around the lips is another important detail in portrait art. If you look closely at people, you will see that we all have this area (a ridge or rim) around our lips. (It is particularly obvious at the corners of the mouth.)

When someone has a five o'clock shadow, this ridge will be especially noticeable. The whiskers won't grow on this ridge.

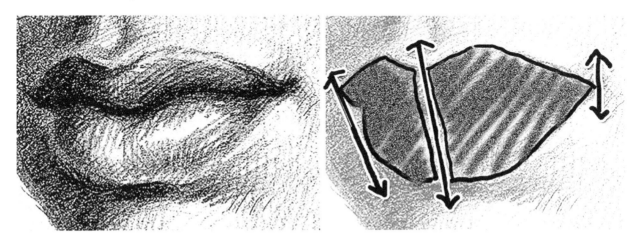

When the face is turned at a three-quarters angle, the mouth takes on a different shape. See how the tilt of the lips becomes more dramatic, starting at the halfway point of the mouth (where the philtrum is located). Also, the two halves of the mouth are now

uneven—the half of the mouth that is farther away now appears smaller.

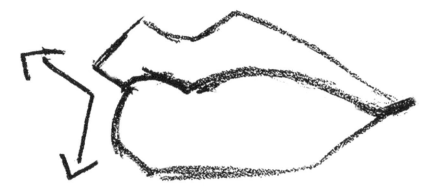

When seen in three-quarters view, the outer edge of the lips take on a different contour on the side of the head that is on the farther side of the face.

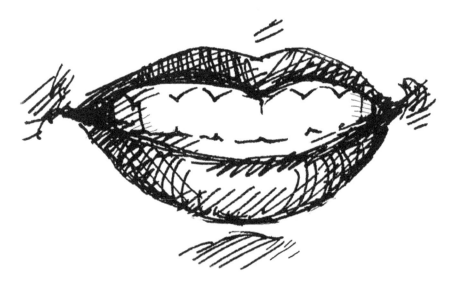

Less is more when it comes to drawing teeth. Do not draw dark lines separating each tooth, even if the model you are drawing has such lines. No matter how faithfully and accurately you draw the teeth, your drawing will not look right. The teeth will look dirty and unattractive. It is better to draw a light indication of the gum-line (if it is visible) and very light line between adjacent teeth. It is even acceptable (and in some cases desirable) to simply suggest teeth by drawing only partial lines between some of the teeth.

Remember that the teeth in the corners of the mouth will be more in shadow, so be sure

to shade these teeth gently and carefully. Often you can put slightly darker dividing lines between the teeth in the corners of the mouth since these teeth are already in shadow.

In this cartoon-like drawing, notice how no lines are drawn between the teeth and yet the teeth are immediately recognizable. Notice how the upper edges of the gum-line are drawn. The bottom row of teeth is drawn with short, small lines suggesting the appearance of teeth. It is also permissible (and often preferable) not to draw any lines on the bottom row of teeth.

In another cartoon-like drawing, see how no lines have been drawn between individual teeth and yet nothing looks amiss in the drawing.

## Anatomy of a smile

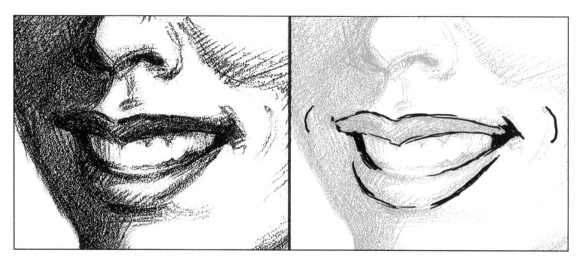

When a person smiles, their upper lip is raised up. There's less space between the upper lip and the bottom of the nose.

The upper lip straightens out when a person smiles. It is stretched out across the teeth. Usually in the corners of the mouth there will be a smile line or dimple line. The smile lines that start at each side of the nose also rise up and become more rounded.

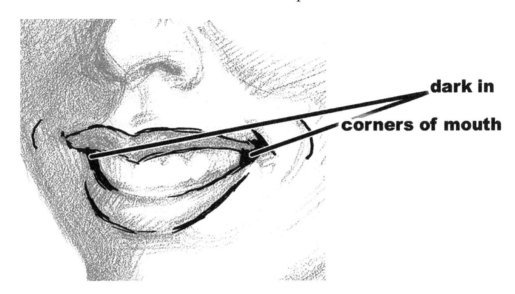

The teeth and jaw curve around the skull—therefore the back teeth are in deep shadow at the very edges of the mouth.

## The mouth in profile

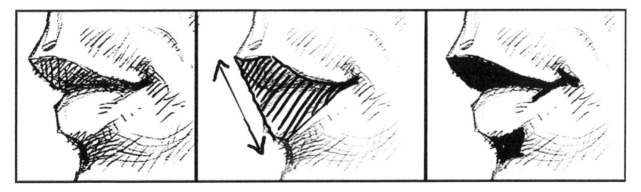

The mouth, like the eye, has a sideways triangle shape to it when seen in profile. As the center illustration here shows, the upper lip almost always tilts out farther than the lower lip. The mouth on the right shows that the upper lip is usually in more shadow than the lower lip. Often, there will be a shadow under the lower lip as well.

## The mouth, step by step

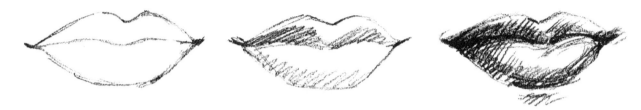

1.   Sketch the outline of the lips.

2.   Block in the shading of the lips, putting more shading on the top lip, and leaving a highlighted area in the middle of the bottom lip and some highlighted areas on the upper rim of the top lip.

3.   Add more shading and rendering. Don't forget the ridge around the lips and the shading around the mouth that suggests its structure. Add the darkest accents of value to the corners of the mouth.

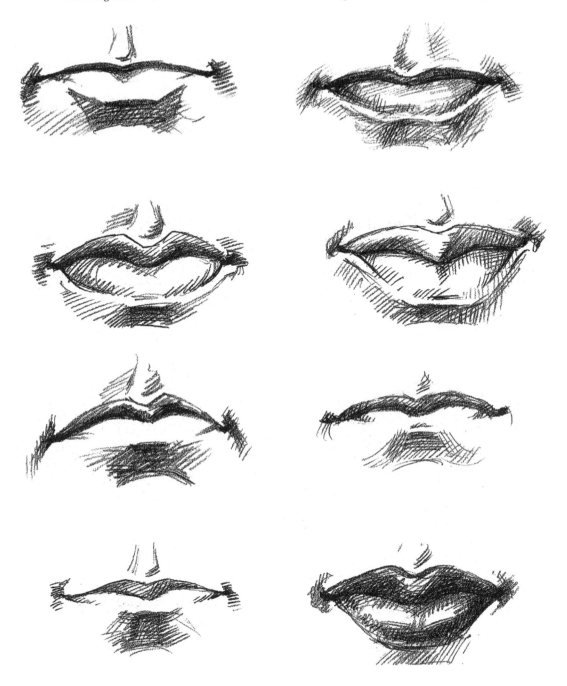

## Page of mouths

Mouths can have thin lips, thick lips, or a combination of a thin upper lip and thick lower lip (it's rare to see a thick upper lip and thin lower lip). Mouths can droop downward or tip upward. All these interesting differences are fun to draw!

## Drawing the Ear

Many of us are tempted to avoid drawing the ear in detail. The ear is as unique as the other parts of the head and if you draw the ears improperly or sloppily, it will be noticed.

Look for the overall silhouette and curve of the ear and draw its outline. You can then refine its shape as you add detail to the ear.

The ear has some elegant curves inside of it, which are outlined in the ear illustration on the right. Look for these curves as you draw the ear. A few simple lines, placed properly, will suggest its form.

Remember again that the ear is tilted back at a slight angle on the side of the head.

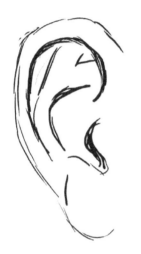 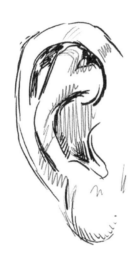 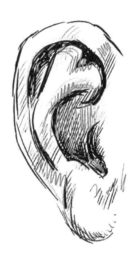 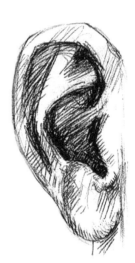

**The ear, step by step**

1.    Draw the outline of the ear and find the primary curves in the ear. Take care to place the ear at the proper angle on the head.

2.    Start to block out areas of light and dark on the ear.

3.    Refine the shape of the ear. Continue to add shadows and erase any alignment lines or curve lines that are now too dark.

4.    Soften up the shapes and curves of the ear and add final details.

# Drawing the Hair

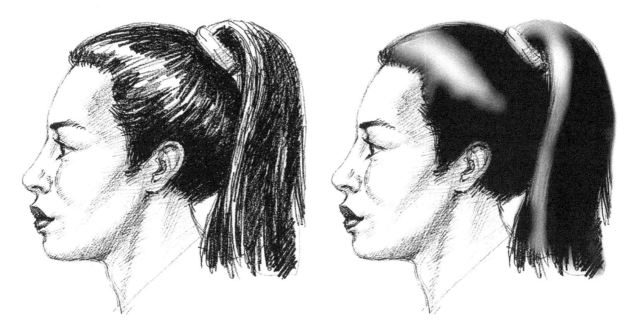

*The hair's highlights and shadows simplified*

There are three things to pay attention to when drawing hair: the hair strands, the values in the hair, and the structure of the head that the hair is on.

Hair is shiny—it has highlights and dark areas. Most hair appears glossy. The first thing you should draw are the shadows and highlights with a broad loose pencil stroke. Don't put in any "dark dark" tones yet; just indicate the shadows and highlights.

After laying down a general idea of where your lights and darks are, you can then draw individual hair strands. Draw dark, sharp pencil strokes to give the hair some crispness. Leave the highlights and midtone areas intact. These distinct variations of tone are what keep the hair looking shiny.

For darker hair, you'll have more areas of dark dark (but still have the midtones and

highlights). For light-colored hair, you'll have very few dark dark tones. The darkest tone in blonde hair may be a medium gray.

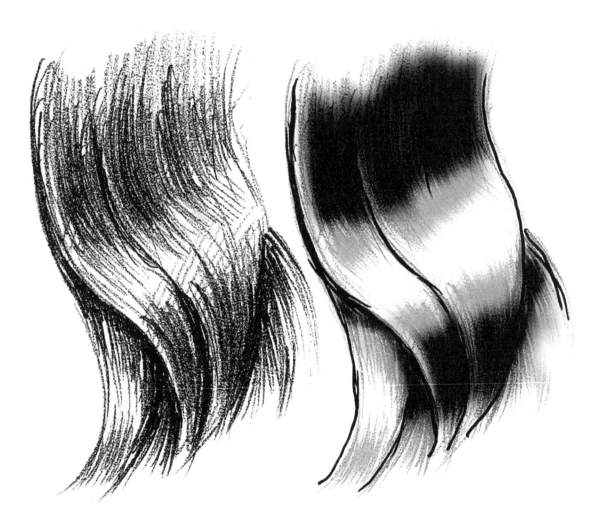

The hair usually collects in layers. Each layer is drawn in first, and it's given its own area of shadow and highlight. When one layer of hair overlaps another layer, it casts a shadow on the hair underneath.

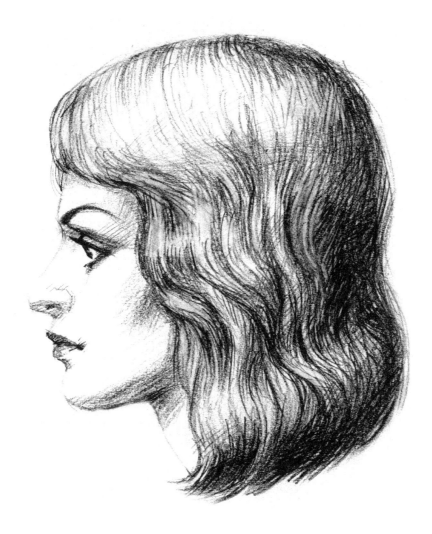

In areas where the hair comes in contact with the face, it'll cast a shadow. Draw in a gentle shadow on the forehead, cheek, jaw, or neck—wherever the hair touches the face. And most importantly, remember that the hair is on a head: the hair should have shadows that indicate that it is covering a round, three-dimensional skull.

## Facial Hair

Beards and other forms of facial hair are not much different from the hair on the head. Facial hair should be rendered with sharp pencil strokes. The structure of the head underneath the beard or facial hair should always be taken into account as well.

The beard or mustache has highlights, just like other forms of hair.

# CHAPTER SIX

# AN OVERVIEW OF THE ANATOMY OF THE HEAD AND FIGURE

## Landmarks of the Head

Now that we've covered the features of the face, it's time to discuss the head's structure a little more. I won't trot out a picture of a skull here (believe me, I considered it), but I will show you a few major landmarks of the head.

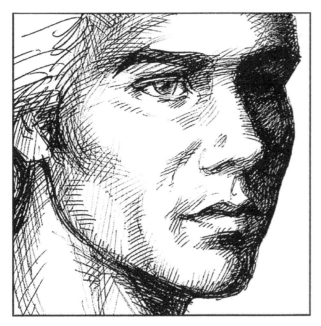
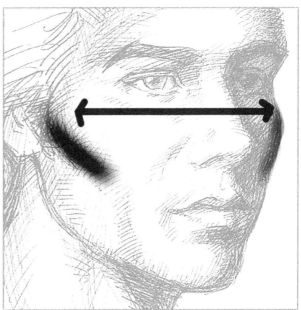

The cheekbones are hard to miss. It's important to remember, however, they should be shaded softly—no harsh lines!

In anatomy, the cheekbones are called the *zygomatic arch*. Feel your own cheeks and follow this bone back to the center of your ear.

Take note of the direction and placement of the cheekbones. On some faces the cheekbone is not very prominent and only a soft shadow is visible.

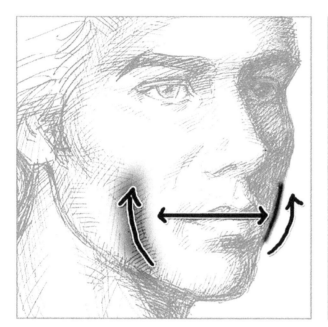 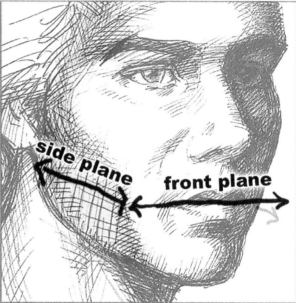

The "dimple line" can be defined as the area of the cheeks where the front plane of the face curves, or makes the transition to the side plane. The dimple line will be emphasized in people that are smiling or grinning, but it is visible in many people even when they are not smiling. Be careful to draw this area with delicacy and a light touch—don't overkill with dark or hard lines. In some lighting situations, this area will hardly be shaded or rendered at all.

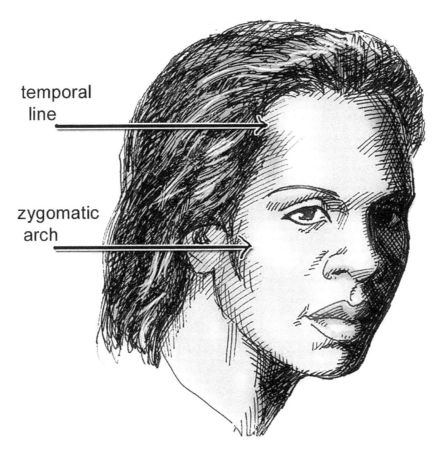

temporal
line

zygomatic
arch

The temporal line of the skull indicates where the front plane of the forehead curves back
to the side plane.

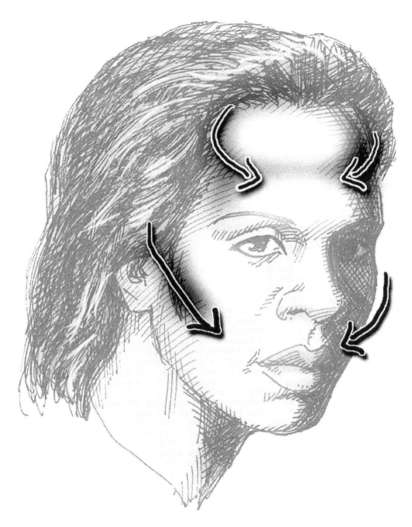

You'll see a bulbous area on the forehead (curved arrows on above illustration). Some people's foreheads will get a heavy furrow in this spot, but for many people, it'll only be visible as a subtle round area near the temples.

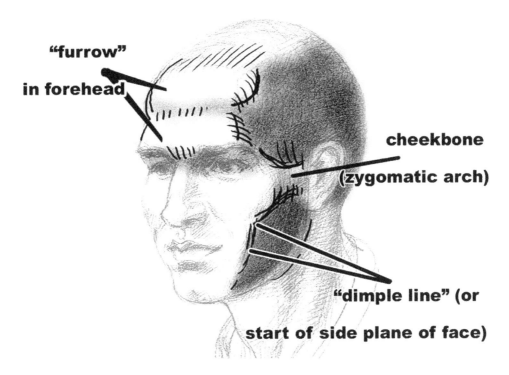

**"furrow" in forehead**

**cheekbone (zygomatic arch)**

**"dimple line" (or start of side plane of face)**

The Happy Bald Guy is again pressed into service—this time, to further illustrate these landmarks of the head.

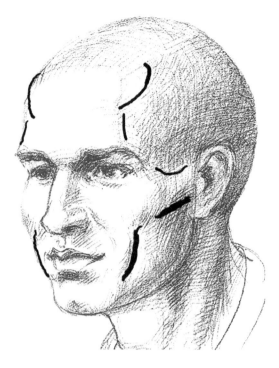

When you are drawing in a loose, simple style, the above lines might be the only ones you'd use to show the dimple line, the cheekbone, and the subtle furrow in the forehead.

## How to draw glasses

To draw glasses on the face, it is necessary to take into account the perspective of the front and side planes of the head.

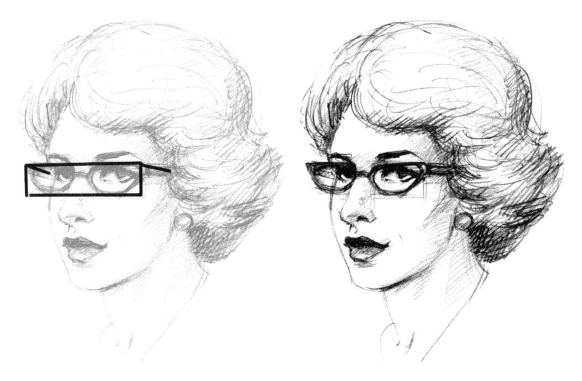

In the illustration on the left, you'll see that the glasses are aligned with the angle of the eyes and brow. To get the placement of the glasses, simply draw a rectangle—the top line should be parallel with the brow-line (above, below, or along the line of the brow, depending on the glasses style). The bottom of the glasses usually is around midway down the nose.

When you have drawn the rectangle, fill in each lens shape, then the rest of the details that make up the glasses frame. When you have finished refining the glasses, the rectangle outline can be erased.

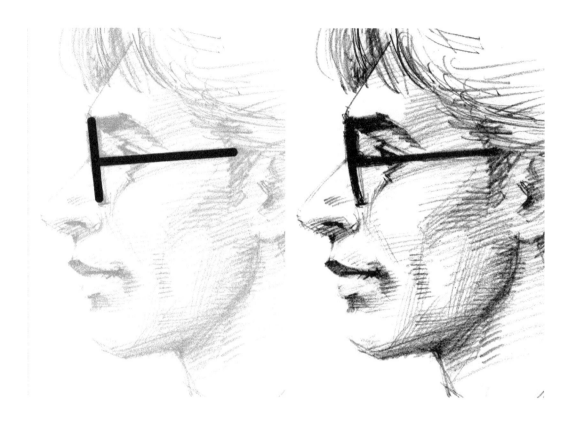

Drawing glasses from the side can be quite straightforward. Draw the side piece that goes from the glasses lens to the top of the ear, and draw a vertical line that indicates the lens itself. This will resemble a sideways "T" shape. Don't forget to draw the shadow that the eyeglasses will make on the nose and cheek!

## The neck and shoulders

A big stumbling block for some portrait artists is trying to figure out the neck and shoulders. It's actually quite simple once you understand the basic anatomy.

1. Sternomastoid
2. Trapezius
3. Clavicle (collarbone)
4. Deltoid

Coming from behind the ear and going down to the pit (middle) of the throat is a large muscle called the sternomastoid (#1). Actually, you'll see that the arrow points to two portions of this muscle; one part of the muscle sort of peeks out behind the other.

No matter how a person's neck is turned, this muscle will follow—it'll always start from behind the ear and attach to the pit of the throat. Check your own neck in the mirror. Feel your neck and see if you can find the muscle. It is the most prominent muscle on the neck.

The muscle on the shoulder area is the trapezius (#2). Its name is easy to remember because it is named after the trapezoid. It is a large muscle on the upper back and back of the neck. You'll see part of it from the front and side.

The clavicle, or collarbone (#3), always attaches to the pit of the neck. (The sternomastoid attaches to the clavicle at the center of the neck.) The clavicle stops at the top of the arm, or the edge of the shoulder.

The muscle on the upper arm is the deltoid (#4). It's a large muscle that attaches to the clavicle (collar bone), and extends down the arm. The clavicle always attaches to the deltoid. When you lift your arm above your head, the clavicle lifts up too, because it's attached to the arm and the deltoid. Rotate your arm around, and feel the clavicle move around too!

In between the two sternomastoid muscles is the adam's apple. It is more prominent in men than in women.

These muscles and bones all line up. They are not hard to remember to draw correctly. If you ever get confused, just look at your own neck, collarbone, and deltoid muscle!

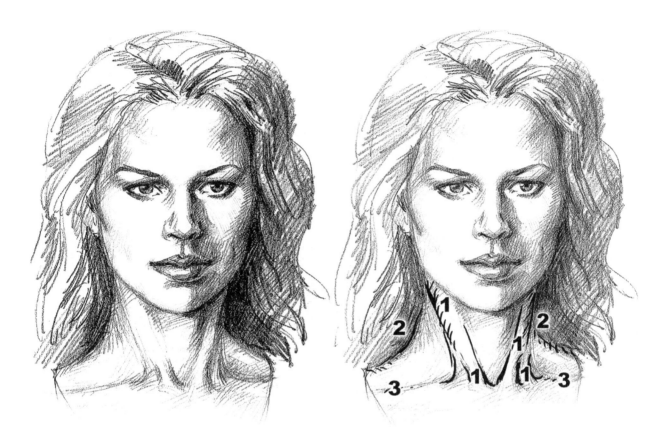

Another view of the neck: #1 is the sternomastoid (notice how part of the muscle peeks out right near the pit of the throat). #2 shows the silhouette of the trapezius. #3 shows the collarbone (clavicle).

*The sternomastoid muscle is often less noticeable on women and children.*

Sometimes, only a few lines are needed to suggest the sternomastoid muscle.

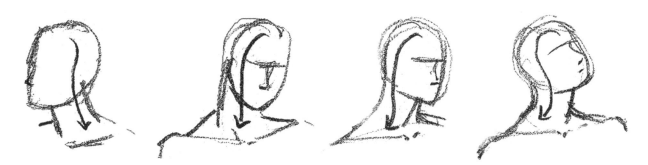

Always be mindful that the spine connects the head to the neck. The spine twists and turns as the head tilts and rotates.

## Proportions of the Body

While the proportions of the entire body do not directly relate to portrait drawing, they are something that I felt was important enough to include in this book. There may come a time when you will wish (or be expected) to draw the entire figure.

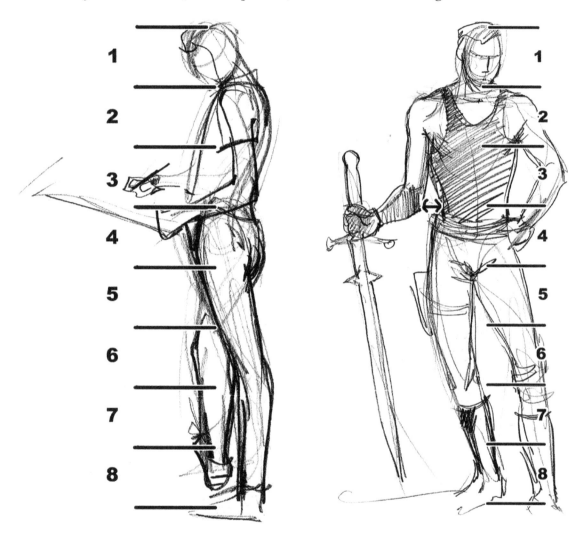

Above are some quick figure studies. You will see that the lengths of their bodies are divided into eight numbered sections. Each of these sections is equal in measurement to the height of the head.

Both models are approximately eight heads high. Seven to eight heads high is pretty normal for human beings. (Even six and a half heads high is not uncommon.) Most artists

consider eight head lengths to be ideal.

Even though people can come in various proportions, often it doesn't look quite right when drawn on paper. We accept what we see in real life, but when we see the same thing depicted in artwork, we question it and wonder if the artist made a mistake.

So, it is acceptable (and in fact strongly encouraged) to lengthen the proportions of the figure in your drawings. Eight head lengths is considered the norm. Seven and a half can also be acceptable, and is fine for shorter or more petite people. Eight and a half heads is recommended for a taller or more heroic figure.

The head lengths align on most bodies this way:

1. First head length: head!

2. Second head length: chest-line at nipples.

3. Third head length: waist-line, at bellybutton.

4. Fourth head length: groin area.

5. Fifth head length: a bit above the knee.

6. Sixth head length: just below the knee.

7. Seventh head length: mid-calf.

8. Eighth head length: at bottom of feet.

**Other measurements that should be noted:**

- When the arms are at the side, the wrist bone aligns with the groin area.
- The elbow aligns with the waistline—around or above the bellybutton.
- Shoulder width, side to side, is about two to two and a third heads wide.

When it comes to drawing figures, one of the most common beginner mistakes is to make the head too big for the body. In addition, many new artists will make the legs too short. Let me emphasize this point again: *it is very, very common to make this error.*

It is almost inevitable that every new artist will shorten the proportions of the figure. I fell prey to this myself when I first started drawing figures. I created horrible, misshapen things! I was quite mortified, since I considered myself to be a reasonably competent artist at the time. It was a grave blow to my ego to see how poorly I had drawn the figure's proportions. But, with practice and awareness, I overcame this tendency, as everyone will when they persevere.

I can only encourage everyone to learn from my (and many others') mistakes. Measure and check these proportions! Do it before you put any dark lines down on the drawing, so that any errors will be easier to erase. Measure everything. You'll avoid the common pitfall of making the figure too short, or the head too big.

If you can't remember the proper arm lengths, just check your own body. For instance, if you ever forget the placement of the elbows, you only have to stand with your arms to your side to find out where your elbows line up with the rest of your body.

If you want to learn more about how to draw figures, I suggest that you take a life drawing class. (This is where you will draw partially clothed or even naked models.) Don't let the nudity give you the wrong impression: these classes are very challenging and serious. Everyone in class is too busy trying to get their drawings right to worry about nudity! No inappropriate behavior is tolerated.

Many artists (including American illustrator Norman Rockwell) have studied life

drawing and figure drawing. It's an integral part of an artists' education.

To learn more about drawing the entire body, check the bibliography (at the end of this book) for a list of some great books, including some excellent ones on figure drawing and anatomy.

# CHAPTER SEVEN

# SHADING THE PORTRAIT

## Understanding Shading for Portraits

In an earlier tutorial on shading (shading the sphere) you were introduced to the concept of lights and darks and how they create the illusion of dimension and depth.

Now we are going to discuss shading for portraits.

Ah, another bald guy. This one seems to be more introspective and serious (compared to the Happy Bald Guy, anyway).

To see the areas of shading in the face, it might be easier to see the tones of the portrait broken down to large areas or shapes.

In this illustration, the details and lines have been removed from the portrait, exposing only the basic large shadows in the face. We need to see the picture broken down into four or five tones, so we can more easily identify where the areas of light and dark should be placed.

You can see that there are shadows on one side of the head, in the eye socket area, on one side of the nose and mouth, under the chin, and on the neck. It is important to identify

these large areas of shadow in every face you draw. Don't get caught up in all the minute detail right away. Leave that for the end, when you are putting the finishing touches on the portrait.

The above illustrations are blurred and the portrait is made up of dots and blobs. The shading alone suggests that these pictures are a portrait of a man. There are no lines or fine details—just general areas of light and dark. The areas of light and dark tones suggest his facial structure. The viewer's eye fills in the missing detail.

Most artists start a portrait by putting in these general areas of light and dark in their drawing. Only after the areas of light and shadow are laid down does the artist work on details such as refining the features and rendering hair, clothing, and background.

## Shading explained

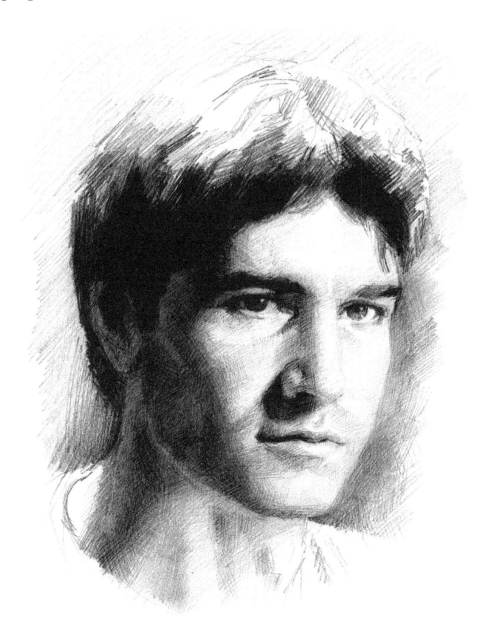

*"Jason" pencil on paper. Based on a photo of Jason Aaron Baca (jasonaaronbaca.deviantart.com) by photographer Portia Shao (positivevista.com).*

The best way for me to explain shading is to use some large illustrations and go through each fundamental concept, step by step.

As you know, shading can be broken down into several values, from blacks, to dark

grays, to middle grays, lights, and whites. Each of these tones will usually be represented in your portrait and you must understand how to identify and shade them in correctly.

A lot of your shading will depend on the overall key of the portrait you are drawing. If you are working on a portrait that is set mostly in shadow (low key) then a lot of dark darks will be used. A high key (wispy, pastel, faded) portrait will have few blacks, but more light grays.

Most portraits have a balance of light and dark values, but many new artists initially have trouble getting these tones represented correctly. They are particularly timid when it comes to dark shades. The darkest they'll get is a medium gray, which they'll use in areas that really should be black (black hair, the black of the pupil, etc.)

It is best to put the darkest values in the drawing last since they are the hardest to erase. But they must be drawn in, or the portrait will look washed-out and faded.

Representing all the tones properly in a portrait will create the illusion of depth, expression, or mood—the contrast of light and dark can enliven the face.

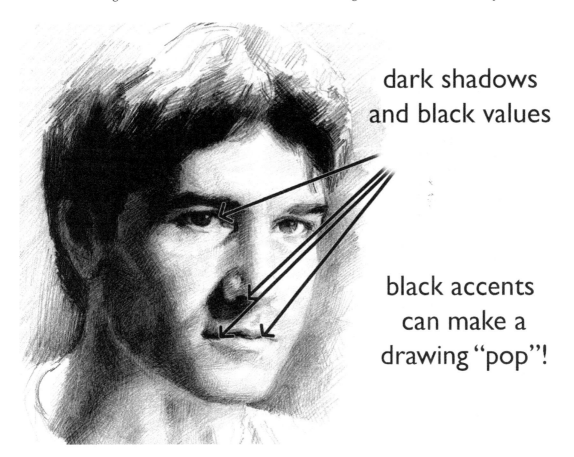

dark shadows
and black values

black accents
can make a
drawing "pop"!

The above illustration points out the dark darks (blacks and near-blacks) in this portrait. Not surprisingly, the shadowed side of the face has most of these dark tones. The corner of the mouth, the pupil, the nostril on the shadowed (left side) of the face, under the chin (on neck), and the shadowed part of the eyebrows are the darkest areas.

In some cases, the darkest values can be effectively used like accents—just a touch here and there, enough to give the portrait crispness and punch.

Whenever dark dark shades are used, they must be black. Not medium gray, but black. Very, *very* black. When you have almost finished your portrait and are pretty sure that everything is drawn in correctly, don't hesitate to bear down a little with your pencil. Use a softer pencil lead (2B, 3B) and *punch in those darks!* If someone has black hair, they have *black* hair—not a wimpy gray. Pupils of the eye are almost always *black.*

The best way to get those black values with pencil is to build up your tones. Use a soft-leaded pencil (2B, etc.) and patiently layer pencil strokes over and over.

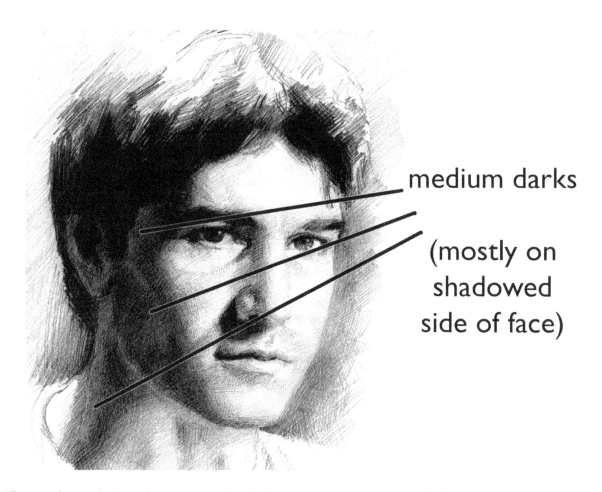

medium darks

(mostly on shadowed side of face)

The medium dark values are used a lot in most portraits, especially in the shadowed areas of the face. They are quite dark, but not so dark that they obscure blacks and dark darks. In this portrait, they are used mostly on the shadowed side of the face, under the eyebrow and eye socket, around the mouth, on the shadowed part of the nose, etc.

Just as it is important to get the dark darks correct, it's also vital to represent the medium darks properly. Wait until your drawing is almost complete and you are sure that you have ironed out all the errors in it. Then bear down on your pencil and don't be shy about drawing in the medium darks! You don't want the dark darks to look too isolated and lonely, do you?

You should make your medium dark values strong enough to have some punch, but not too close in value to the darker shades. Work on building up the tone with your pencil, working and rendering an area until you feel it has reached the desired

darkness. If you feel you have gone too far, "pat pat pat" the area with your kneaded rubber eraser to lighten it up a bit.

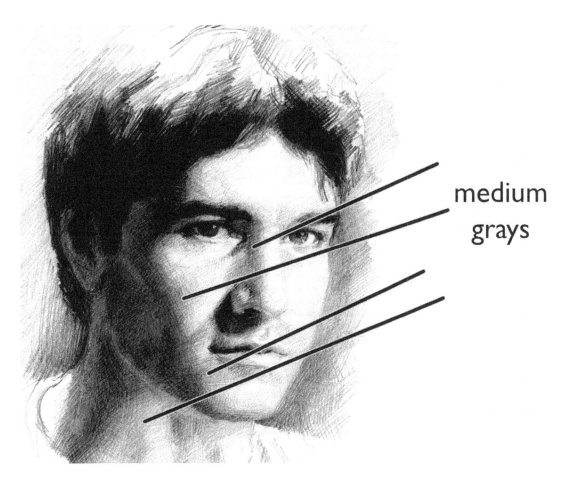

medium grays

The medium values can be the trickiest. You might feel reluctant to put them in as dark as they should be drawn. Many newbie artists have used a medium shade for areas that really should be black! (Pupil of eye, etc.) Drawing the right values in the proper areas can take some getting used to, but don't be afraid—you can do it!

Medium values are usually used to make the transition of dark areas to lighter areas more gradual and smooth. Without medium tones, the portrait would look harsh and severe. Medium values give the drawing a more cohesive, realistic, and natural look.

In this portrait, you'll see that parts of the shadowed side of the face have a medium gray. The medium value is used to give shape and modeling to the lighter side of the face. The

edges of cheekbones, chin, areas around the nose, etc., were rendered using a medium gray.

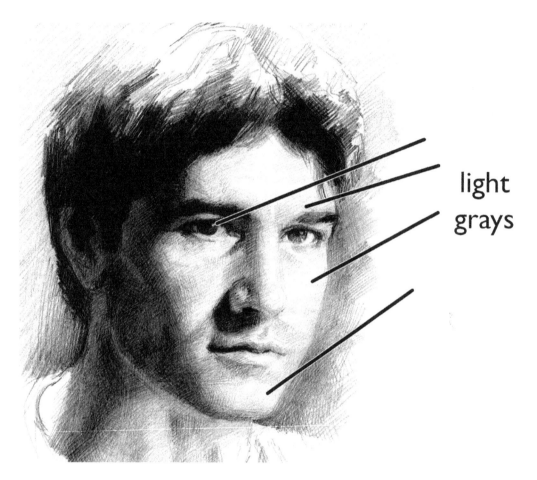

light
grays

Don't ignore the subtle light values. There is a lot of detail in these light shades and if they are neglected, the portrait as a whole will suffer. This additional rendering and blending will make the portrait look more realistic and natural. Sometimes a light, subtle tone will define some important detail of the face, which could be important for getting a good likeness.

Notice in this drawing that the highlight of the eye on the shadowed side of the face is also light gray. We are used to thinking of highlights as white, but it is not always so. A stark white would look out of place on the otherwise shadowed side of the face.

Typically, the highlight on a deeply or moderately shadowed side of the face will be a light gray or medium gray. Very rarely would an eye highlight be white on the shadowed side.

A soft touch must be used for these light values. Look closely at your model to see these subtle light shades. One way to identify the highlighted (white or almost white) areas of the face is to look at the areas right *around* these highlighted areas. Usually, they are just a little darker, which makes them subtle light tones!

In this portrait, the subtle grays are often in transitional areas (going from shadowed to light). These light tones help to show a rounded form (the roundness of the ball of the nose, the roundness of the muscle in the neck, the roundness of the chin or brow). Lighter values help blend the medium tones with the highlighted areas and give the face a dimensional, more realistic look.

Light values will be used to indicate faint wrinkles, a five o'clock shadow, or subtle structural details of the face.

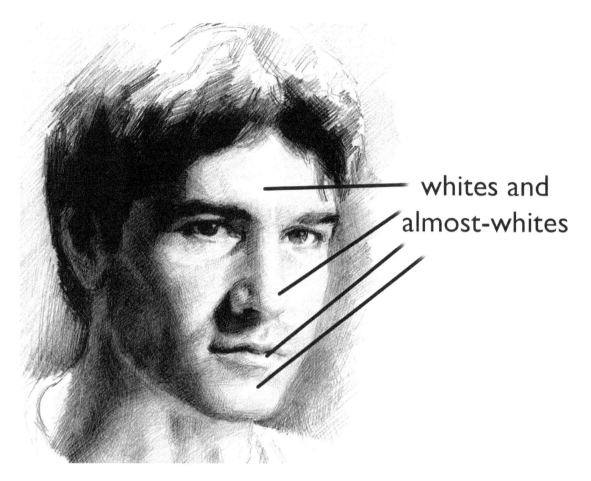

whites and
almost-whites

Sometimes, artists think of the white (or highlighted) areas of their portrait as, "Whatever is left over after I finish shading." But there's more to the white areas than that! Using the light gray areas *around* a highlight will bring it out and emphasize its importance. Highlights add crispness and punch to a portrait. The highlight on the eye, the tip of the nose, the lower lip—these highlights can help bring the portrait to life.

In this portrait, the classic areas (eye, lip, cheek, bridge of nose) have a highlighted spot. These are areas that are usually facing up toward the light source. Therefore, they get more light cast upon them. The eye and the lip are moist, so a highlight can be used to indicate this.

Because of the effective use of subtle light values (as described on a previous page) the highlights stand out, but not too much. They are not too obvious, but they are there and give the face a three-dimensional, realistic feel.

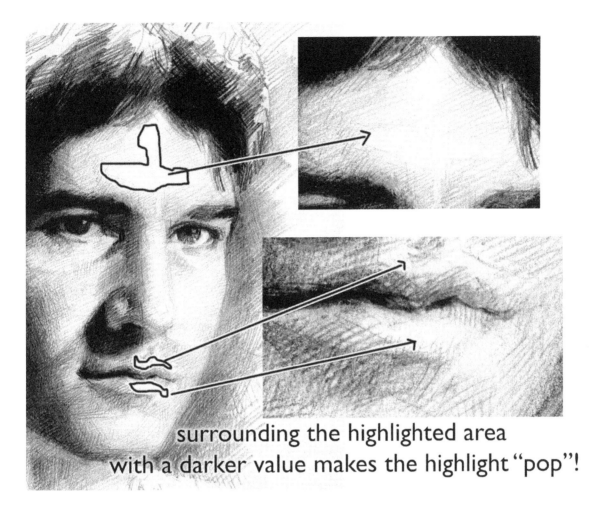

surrounding the highlighted area
with a darker value makes the highlight "pop"!

Here is an additional demonstration of how important those light shades are. When you refine them properly, they make the highlights pop out and lend more realism to the entire portrait! Don't forgo drawing the lighter shades, merely because they seem so faint that you assume they won't be seen. Even though the light shades are subtle, they are necessary.

So, it seems like the two most important ingredients for a dynamic, realistic portrait are strong lights and darks. If all you have are mostly medium grays, your drawing is flat and drab.

## Shading for darker skin tones

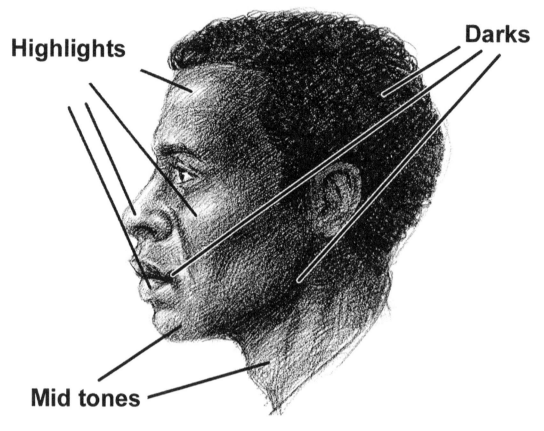

The principle for shading portraits with darker skin tones is the same as shading any other portrait. You will look for the proper values and shade them in.

Depending on the person's skin tone, you might use a darker medium gray. You will end up covering a lot of the face with this gray. Highlights will be a paler gray. Fewer highlights will be white or almost white.

You will be using a lot more dark grays. There will also be more blacks and dark darks, but not as many as you might think. If possible, use the dark darks as accents, like at the corner of the mouth, the nostril, eyes, eyebrows, shadow under jaw, hair, etc.

You'll see that most of the face is dark or medium gray. The highlights are not really white, but more like a light gray. Black values should be reserved for accents (like nostrils, the line between the mouth, etc.), for black hair and only the deepest of shadows.

# CHAPTER EIGHT

# STEP-BY-STEP PORTRAITS AND SOFT EDGES

**Step-by-Step Portrait, Front View**

Materials you will need:

- Sketch paper or drawing paper (8x10 or 9x12 inches is fine).
- HB or B pencil. (If you don't know what that means, just use a #2 pencil.)
- Kneaded rubber or regular rubber eraser.

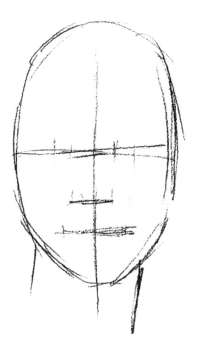

Start by drawing an oval or egg shape.

Draw a straight line across, about halfway down the face, to indicate where the eyes will be. Use this line to make sure you don't get the eyes crooked when you draw them in later.

Place a line about halfway between the eye-line and the bottom of the chin—this will be the bottom of the nose.

A little less than halfway between the nose-line and the chin draw another line—this is for the mouth.

Put a line right down the center of the head, top to bottom, to help guide you and make sure the face is drawn symmetrically and not lopsided.

Draw two lines to indicate the neck.

Draw these lines faintly so they can be erased later. But don't make them so faint that you can't see them!

Review the tutorial earlier in this section, which discusses the proportions of the head.

Now, start to block in basic shapes and shadows. Indicate (somewhat lightly) the shadow areas in the hair.

Start to put some shadows and a little detail in the face. Erase when necessary, but for the most part, keep your drawing loose. Use light, broad pencil strokes and avoid using tight, careful strokes. Just lay in the basic shapes.

View your drawing in the mirror now and then to see what areas are crooked or off kilter. (There are always off parts. For example, in the previous illustration, the chin is crooked. This will be corrected later.) Looking at the drawing in the mirror is usually a shock because you will notice all sorts of strange funky flaws that did not seem at all obvious when viewing the portrait normally. Viewing a flopped version of the portrait somehow allows you to see the asymmetrical areas that you hadn't noticed before. (Some typical flaws might be crooked eyes, a crooked nose, one side of the face wider than the other, or a lop-sided jaw.) Correct these problem areas and keep working.

Keep in mind—every person has some slight asymmetric parts to their face. No one has perfectly even features. In fact, most people look noticeably different if a photo of them is accidentally reversed. However, there is a distinction between a slight funny look and having features that are wildly crooked.

Check to confirm that the basic proportions of the drawing are correct before moving on and putting down darker values. Use the eye-widths measuring method to double-check and verify that everything lines up and isn't too large, too small, or not in proportion. (Compare measurements with the finished portrait that is shown at the end of this lesson.)

Keep your pencil strokes light at first and check the mirror often for errors. Don't be upset or discouraged when you see flaws and wonky areas—making such mistakes is very common.

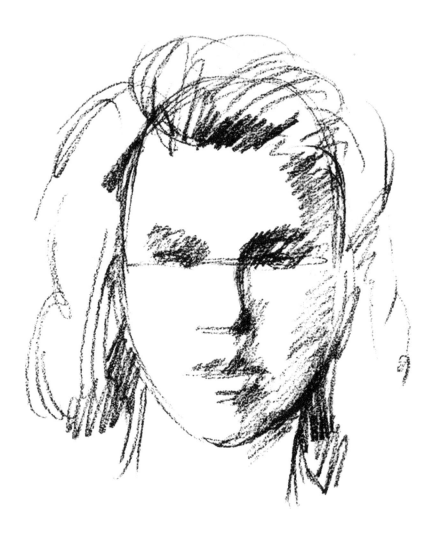

When you decide that the proportions of the face are accurate, start to refine your rendering of the portrait.

Erase the extra alignment lines you drew in the beginning of this portrait and also get rid of any extra loose sketching lines you made when you were getting the feel and structure of the face.

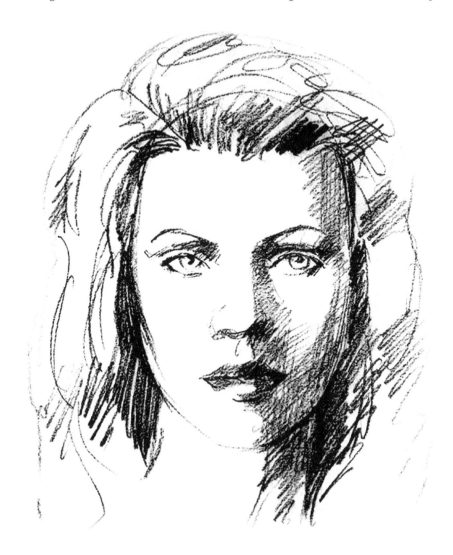

Start to add more detail to the eyes, nose, and mouth. Draw details like the pupil of the eye, define the area around the lips and nostrils, and so forth. Continue to work on the shadows and rendering in the face.

Don't balk over erasing problem areas and reworking them. When you want to just lighten or subdue an area, remember to gently "pat pat pat" with your eraser. Learn to have a light touch when erasing!

Still consult the mirror to see if you have inadvertently made something asymmetrical. Constant vigilance is needed in this regard, especially with front-view portraits (like this one). It is quite easy to get the features lopsided from the front view.

If you are having trouble with your drawing or are feeling increasingly frustrated with a problem area, put it away for a spell and take a break. Frequent breaks can be very helpful and will save you time in the long run. Don't keep on reworking and fussing and reworking and getting increasingly frustrated (and maybe messing up your drawing in the process). Get away from the drawing for an hour (or day) and work on another drawing or just do something different for a while. More than likely when you return later, you will find the issue that so vexed you before does not seem so bad anymore. Trust me on this one—there are times when it's wise to tell yourself, "That's enough for now." It'll save you a lot of mistakes and headaches.

*The finished portrait*

Don't worry too much about making the portrait look exactly like the one here. Just get the proportions correct, make sure to have a proper range of light and shadow (as described in the lesson on shading), and confirm that the portrait looks mostly symmetrical when seen in the mirror.

If you have trouble with your drawing, don't worry. It sometimes happens to all of us. Consider every effort you make to be one more step toward your own personal excellence. Be proud of yourself and keep on practicing!

## Step-by-Step Portrait from a Three-Quarters View and Using Soft Edges

Drawing a portrait from three-quarters view is sometimes more of a challenge, but it can also be a lot of fun! In this tutorial you will also learn some new techniques for shading and rendering.

Use the same materials in the previous step-by-step tutorial (pencil and kneaded rubber eraser). Periodically use the mirror technique to check for errors.

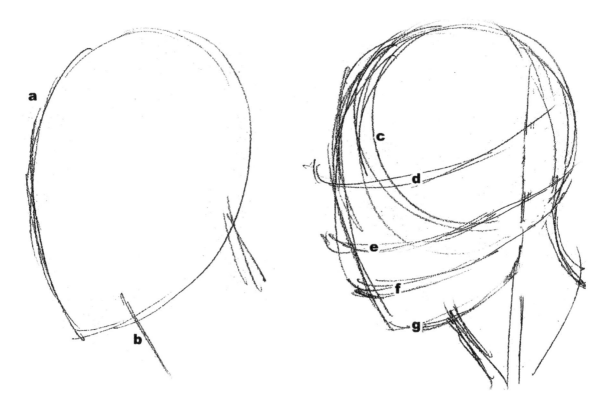

Start this portrait by drawing an oval shape that is more round on the right side than on the left side (a). Draw two sketchy lines to indicate the neck (b).

Next, draw a circle in the back of the oval (c), similar to the circle that you draw when starting a portrait in profile. Place a line (d) a little above the middle of the oval and imagine that this line is going around this oval. This will become the line where you will start the brow area on the head.

Draw another line halfway between the middle line (d) and the chin area (g). This will be the nose-line (e).

Draw yet another line, a little less than halfway between the nose-line (e) and the chin area (g). This will be the mouth line (f). See the illustration on the above right to see where these lines are placed.

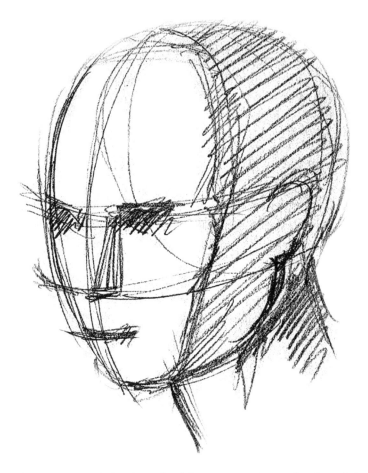

Draw a line down the center of the head. Of course, since the head is at a three-quarters view, the center will be closer to the left edge of the face (the left side of your paper).

Lay in some shadows where the eye sockets should be. These eye sockets will line up with the first alignment line you drew previously. Each eye socket should be located on either side of the center line that you drew on the head. Sketch these tones in loosely but don't make them too dark yet.

Indicate a nose by drawing a triangle wedge that is sticking out from the oval shape that is the head. Start this wedge in the area between the shadow of the eye on the right side of your drawing. Now, draw a line indicating the position of the mouth.

Start to lay out a shadow for the right side of the head. Remember that this head is egg-shaped. Think of it as sort of a modified sphere and recall how you shaded the sphere in the shading tutorial in Section One of this book.

Put down some shadow on the neck. Imagine that the neck is round, like a cylinder, and shade the right side of this round neck.

Sketch in the jaw-line. See how the line of the jaw starts to tip up and meet the ear. If you were to draw a line straight back from the mouth, that line would align with the place where the jaw starts to curve up towards the ear.

Indicate the outline of the ear. Remember that the ear is placed at a slightly tipped angle on the side of the head. Also make sure that the top of the ear is lined up with the eyebrow line and the bottom of the ear lines up with the bottom of the nose.

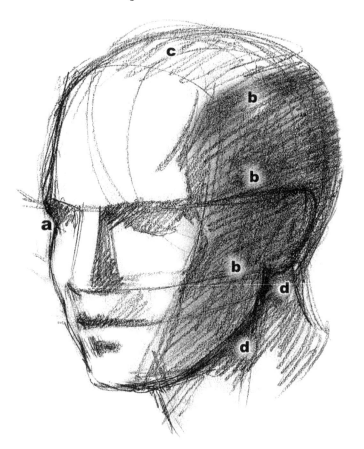

Refine the shading on the head. Use shading to make the nose a definite wedge shape. Lay down a shadow on one side of this wedge while leaving only a light line on the other side of the wedge.

Draw a brow-line (a) on the left side of the head (the side of the head that is on the left side of your paper). The outline of the head dips in here to allow for the eye socket area. Redraw the chin area (make it a little more square) if you feel that your original sketch has a chin that curves in too severely.

Continue to add shadow to the right side of the head. There is a definite side plane to the face (b). Shade this side plane (right side of head). The front of the head (where the features are) is facing the light source and therefore will not get as much shadow.

As you can see, the top of the head is on a somewhat curved plane—there is a point where the side plane of the head (b) curves to become the top plane of the head (c). The top of the head has less of a shadow on it.

Start to draw a definite shadow around the line of the jaw and the neck (d). Use this shadow to separate the neck from the jaw. This shadow should be darkest right under the jaw and under the lobe of the ear, because these areas will not get much light.

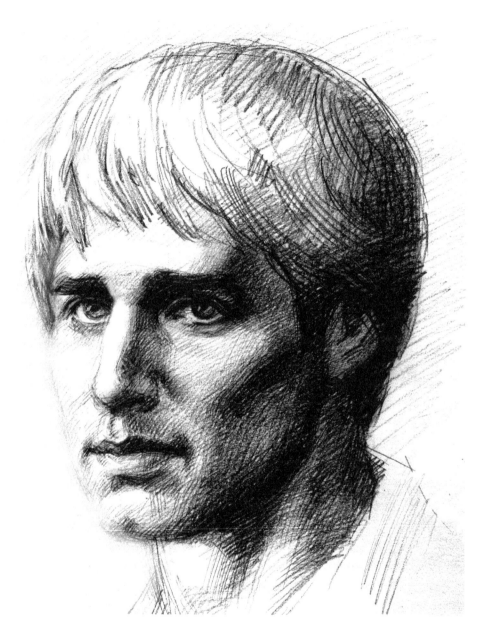

*Finished three-quarters view portrait*

Yes, you are still expected to draw all the shading of the skull (this time), even though you are only going to cover most of it with hair!

Understanding the structure of the skull and being able to shade it knowledgeably will make you a strong portrait artist.

To complete the portrait, continue to refine the details of the face. Erase alignment lines and lighten up some of the shading in the eye sockets (if necessary) to draw the eyes.

Don't neglect to render the large muscle in the neck that starts from the base of the throat and goes up to the bottom of the ear (right behind the jaw). Review the tutorial on the neck and shoulders if necessary.

Notice the shadow that is between the eyes (on the bridge of the nose) and on some of the forehead. This shadow over the brow is not uncommon, so take care to look for it and draw it when it is present in any of the people you draw.

Have fun making the portrait, and as always, make sure to check your drawing in the mirror to confirm the all the features are lining up correctly.

## Using soft edges to create dimension

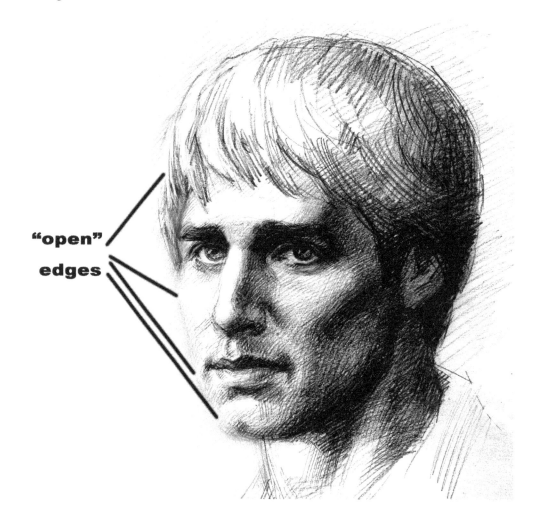

"open" edges

In the finished portrait there are no harsh lines on the highlighted (left side) of the portrait. The edge of the face actually has open areas where there is no line at all.

See how many open areas you can put in your drawings. Look for edges of the face that are in highlight and see how your drawing looks when you don't outline these edges. Most likely the portrait will look natural and have a little more depth.

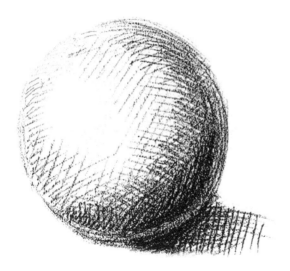
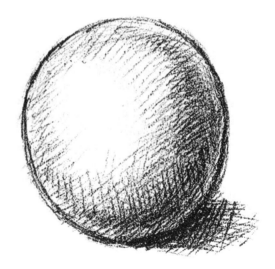

Here is an excellent use of open areas and soft edges. Both of these spheres were drawn in exactly the same way, except for one difference. The sphere on the right has a heavy outline, which seems to flatten the drawing. The sphere on the left has open areas where only faint lines are used.

Look for ways to avoid outlining the shapes and forms in your drawings; instead, indicate borders and edges by the use of shadow or light.

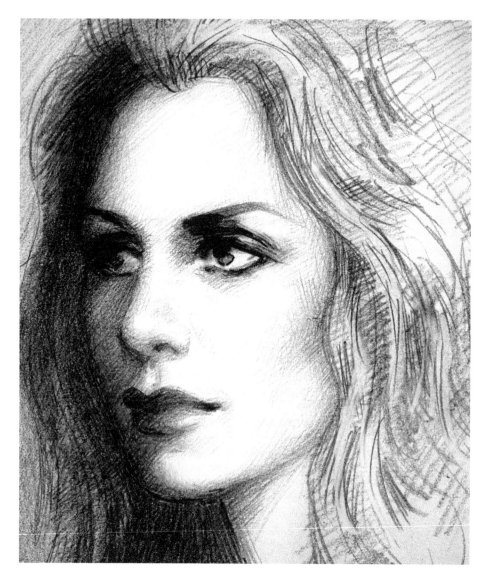

Notice how many of her features are not heavily outlined. Her nose, cheeks, and other structures of the face are softly defined with values, rather than with strong defining lines. There is only a soft definition of value between the upper and lower lips. (Caveat: I added a vignette filter in Photoshop to this drawing, so the outer border has a gently darkened appearance.)

# CHAPTER NINE

# WORKING WITH A TIGHTER TECHNIQUE

## "Semi-realistic" Pencil Portrait

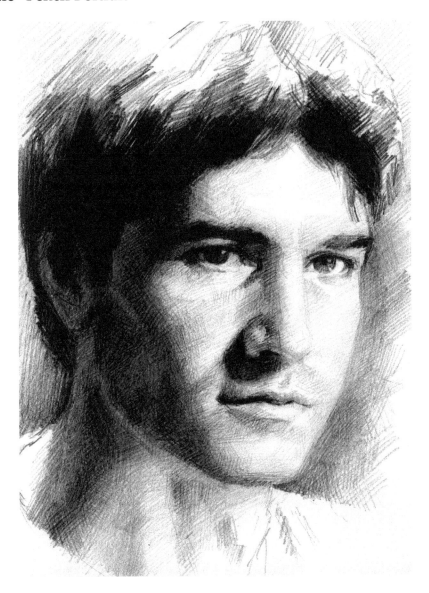

*"Jason" cropped detail. (This isn't an exact likeness of Jason. I made the face too long!)*

"Jason" was rendered using a semi-realistic pencil style. The pencil strokes are still visible, but are more refined and tight.

There isn't much of a secret to drawing in this style; it simply requires an eye for detail, and some patience. I was first introduced to this technique by one of my teachers at art school. He explained it concisely—you just get a sharp pencil and a smooth Bristol board and draw in all the itty-bitty details. His own work is known for its scary realistic detail, so I was amazed to learn that the secret to his fabulous work was so simple.

Consult the step-by-step portrait tutorials in this book to get an overview on how to draw a portrait. Alternatively (if you are using a photo reference), you can use the grid method. (Be sure to review my cautions about relying on the grid method too heavily, however!)

**Materials needed for this drawing:**

Bristol board, smooth finish. (Smooth finish illustration board will also work.) It is important that the paper be smooth and not have a lot of "tooth" (texture). I recommend Strathmore Bristol Board, in the 9x12- or 11x14-sized pads, but other brands will work as well.

For this portrait, I used a .05 mm mechanical pencil. I usually use a B or 2B lead, but this time I only had an HB. It was sufficient. A regular pencil will work fine, as long as it is kept sharpened.

Kneaded rubber eraser. This is invaluable for picking out stray lines, softening tones, and erasing errors. This eraser is suited for erasing small, delicate areas.

To keep smudging to a minimum, use a scrap of paper underneath your hand as you draw. You can also attach a sheet of thin tracing paper over the drawing (as a sort of overlay). This will help prevent smearing as you move the drawing and transport it around. The tracing paper also protects the drawing from fingerprints and dirt.

All preliminary sketching should be drawn in lightly, so that stray pencil strokes can be

erased later. When you feel that you have the proportions of the face drawn in correctly, start adding more detail and shading. Double-check the drawing in the mirror regularly, to make sure none of the proportions have gone astray.

All through the progress of the drawing, use your kneaded rubber eraser to erase any mistakes. "Pat pat pat" the eraser over any area that has gotten too dark. This will lighten the area without smearing the graphite or losing the quality of the pencil strokes. The eraser is also very good at completely erasing an area without damaging the surface of the paper.

Keep adding more detail to the drawing as you go along. All shading should be done lightly at first and then darkened progressively. The sharp point on the .05 mm mechanical pencil will keep all strokes fine and small. It is easy to keep a sharp, detailed look when you use such a pencil.

With this portrait, I made a deliberate stylistic choice to allow the background and hair to be more loosely rendered. The center of focus is the face, not the hair or background. Allowing some pencil strokes to show adds a nice touch and reminds us that it is a drawing, not a slavishly copied photograph. Try to avoid being a human copying machine. Add your own artistic flair to the drawing!

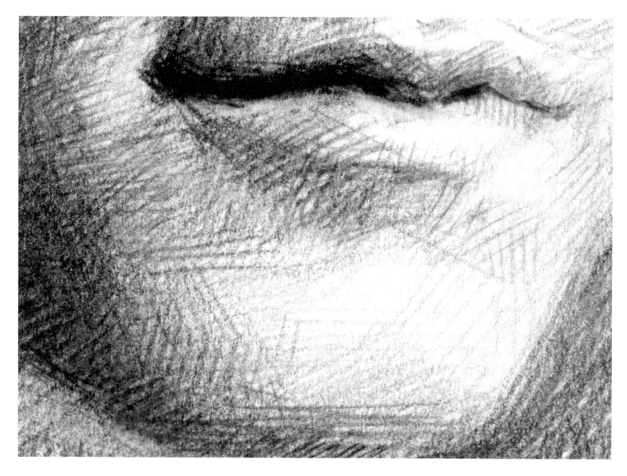

*Enlargement—detail of corner of the mouth*

All the pencil strokes are crosshatched, not smeared or smudged. The gentle crosshatching gives the portrait a clean, neat appearance. It is much easier to control than smudging. Small subtle details are easier to define.

Crosshatching done with tight, refined pencil strokes will look smooth and even photorealistic when the portrait is seen at a normal distance. The tighter the strokes, the closer to photorealistic the final art can look!

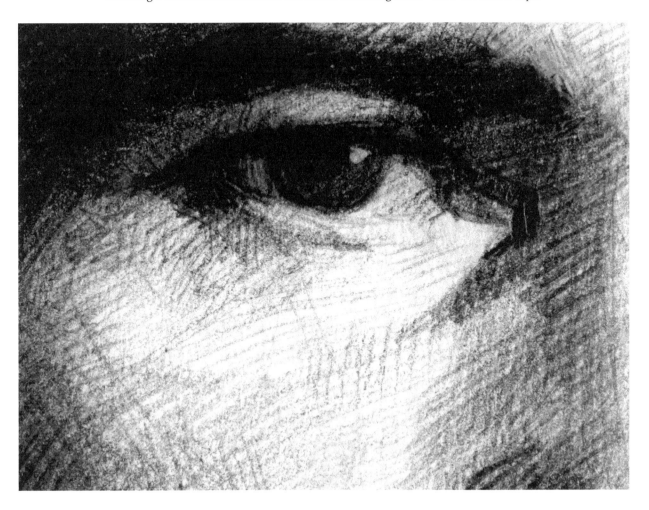

*Enlargement—detail of the eye*

Contour lines used in conjunction with the crosshatching give a subtle but effective three-dimensional effect. This will enhance the realistic look of the portrait.

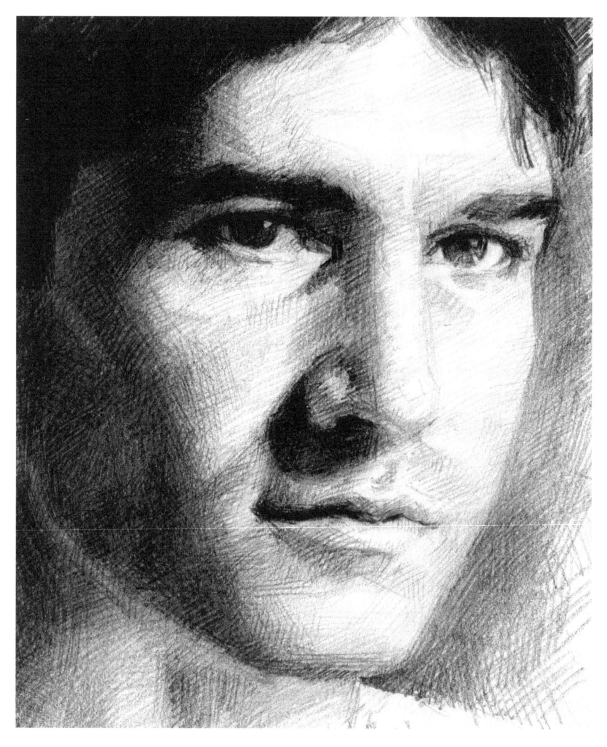

*"Jason," enlarged*

When seen at normal size, many of the light crosshatch strokes will appear to blend together and not be as noticeable. However, the crosshatching technique is not unattractive and needn't be concealed or hidden.

Allow yourself plenty of time to complete this tighter, more detailed style of portrait. This is not a project that should be rushed!

The actual time it takes (in hours or days) to render the drawing isn't as important as the time it takes to declare it "completed." Personally, when I am working from photo reference, I always have to wait a few days before I can really discern whether or not the likeness is there. Getting the portrait drawn and rendered isn't the problem—that can be done in a relatively short amount of time. Capturing the fleeting likeness takes longer and requires some objectivity. Just because the drawing is more or less in proportion doesn't mean that the likeness is also there.

Certain errors and problems probably won't pop out at you until you've slept on it. The likeness may appear to be good when you are working on the drawing, but the next morning you may find that there are a lot of problems. Therefore, it is wise not to rush through finishing the drawing.

## Getting smoother shading when working in graphite

Making your shading look smooth with crosshatching really isn't much of a mystery. One way to do it is start light, and layer, layer, layer these marks over each other. The goal shouldn't be to try to make hatch marks really go completely away, however. With a sharp pencil and a light touch, the lines will become subtle and attractive when seen at a normal distance. I used a sharp .05 mm mechanical pencil in this example.

I did a quick example of a more "blended" crosshatch, and another underneath it that is coarser, showing how the strokes are hatched and layered. This graphic is enlarged; when seen at normal size the blended effect is quite smooth.

# Tips for Capturing a Likeness from a Photograph

### Choose photo references carefully

If possible, always have more than one reference photo of the person you want to draw. Even better is to meet the person you are drawing (if you don't already know them).

Pick your reference photo carefully. Do not be too stubborn about working from a "favorite" photo. Not all photos will make suitable references for portrait art. Some may

look fine as photos but will never translate well to pencil portraits.

In some cases, the photo looks like the model only *because* it is a photo. People will accept an offbeat pose in a photo because they believe that there is no margin for error. Everyone assumes that cameras don't lie, nor will they make mistakes in proportion or expression. However, people will not accept the same offbeat pose in a drawing. They will assume that the artist made an error and did not draw the portrait correctly. It won't matter if the artist copied the photo 100% accurately; the viewer will blame the artist—not the photo reference—for the offbeat look. Avoid using these kinds of photos. They will only cause you much grief and struggle.

Choose a photo that you feel depicts the model in a typical expression or mood. Use your intuition—does the photo really *look* like the model? There is no use in drawing from a photo that is so heavily retouched that it is no longer recognizable as the person you are trying to draw.

If your model is concerned that you are choosing a photo that they don't consider flattering enough, remind them that you can always soften up wrinkles or in other ways downplay perceived "flaws." I would caution you to use a light hand when doing this, however—too much of it and the likeness will be completely lost.

## Have a feel for your model

Give yourself time with the portrait and open your mind to the *feel* of the likeness. Sometimes the best portraits aren't 100% accurate and correct, but the spirit of the likeness is there. This sounds like an artsy-fartsy method, but it definitely has some merit. There are times when the process of capturing a likeness has an almost spiritual element to it. It is not enough to merely render a face by copying the lights and darks of the face with accuracy. You must have an *understanding* and *feel* for the person you are drawing. This feel may take a while to develop and recognize, but it is in you—so be open to it and cultivate it.

**Don't draw someone you don't like**

If you have to *imagine* something good about the person you are drawing, do so. Or, if you are in the rare circumstance of drawing someone who is impossible to like (a portrait of a murderous dictator, for instance), use your strong *feeling* about that person to help you get the likeness.

# CHAPTER TEN

# DRAWING DIFFERENT TYPES OF PEOPLE

## Comparison Between the Male and Female Heads

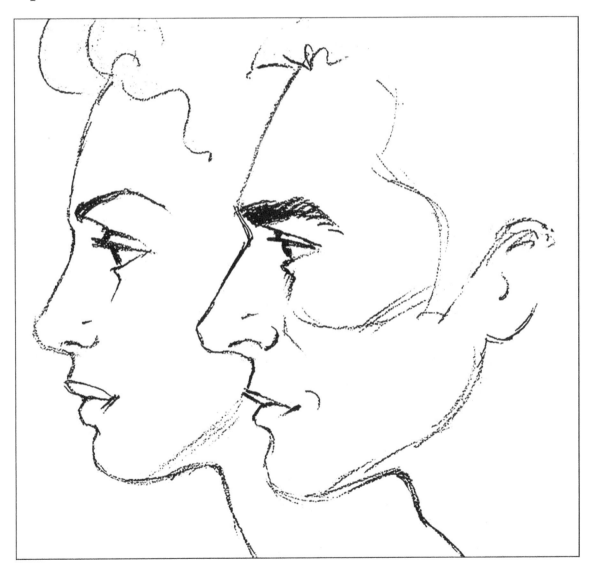

## Some differences between the male and female face

- Men have stronger, more angular features.
- The "brow-line" (where the forehead meets the bridge of the nose) usually dips in more and is more pronounced in men. Women have a more subtle or rounded brow-line.
- Men's foreheads are often more sloped than women's foreheads.
- The jaw is stronger and more pronounced in men. Women frequently have softer and rounder jaw-lines.
- Women often have fuller lips (or at least, a clever use of makeup can give them the illusion of fuller lips).
- Men can have larger and more angular noses. Women tend to have smaller and rounder noses.
- The chin is often narrower and shorter and has a softer curve in women. Men often have more jutting and prominent chins.
- Men usually have heavier eyebrows.
- There is a noticeable "Adam's apple" in men, while women have smoother necks.

Of course, for every one of these "rules" about the differences between male and female faces, we all can think of some notable exceptions. There are women with thin lips, men with full lips, women with strong jaw-lines, men with softer jaw-lines—and all these unique variations somehow look natural and attractive on the individual person. Once again, it is always desirable to observe the person you are drawing carefully and identify their unique characteristics.

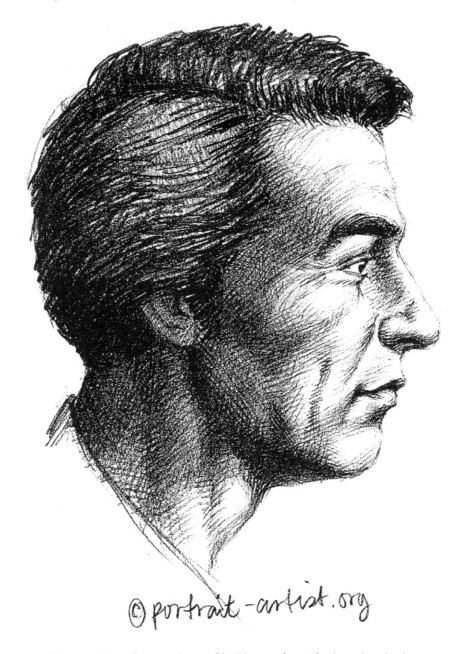

*Bruno—Pencil portrait, profile (drawn from the imagination).*

This fellow has a slightly receding chin. It fits his face and overall appearance and looks natural for him.

# Differences in Age and Race

To do this subject justice and to discuss the many differences between people of different ages and races would be too daunting (and lengthy) of a task to undertake for this book. However, a few tips and guidelines can be offered.

## Children

- In children, the eyes are bigger in proportion to the head. The eyes are almost adult-sized. The head is bigger and rounder in proportion to the features of the face.
- The child's neck is narrower and more upright (not so much at a slant).
- A child's cheeks are chubbier, their noses are smaller and tend to be more flat, and their ears are bigger in proportion to the head.

## Older people

- In older people, the lips thin and often recede.
- On some individuals, the cartilage areas (ears and nose) get larger and fleshier.
- The flesh in the face and neck will sag and become droopy.
- The cheeks become less plump and begin to flatten and droop.

## Racial differences

- Observe the face in profile. Members of certain races tend to have an extremely rounded or receding profile, while people of other races have profiles that are very straight up-and-down.
- The length, width, and overall structure of the head are often similar within certain racial groups.
- Take note of unique features of individuals—do they have thin lips, thick lips, narrow noses, or wide noses? What kind of brows do they have? What shape of eyes? The different variations are fascinating and endless!

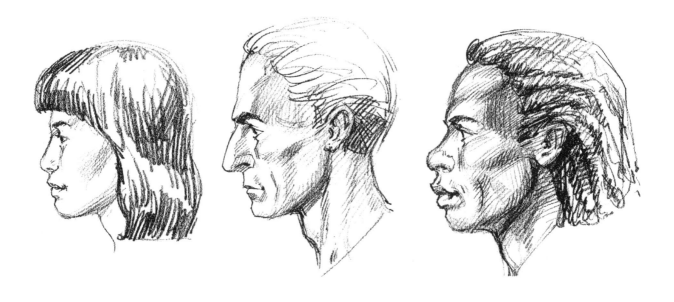

The distinctions between the various races are often most evident in the profile—some profiles are more curved, while others are more straight up and down. Other racial differences might be the width of the mouth, the size of the nose, and how deep (or shallow) the eyes are set in the face.

## CHAPTER ELEVEN

## INVENTING YOUR OWN PORTRAITS

## Drawing Faces from Your Imagination

As you've probably figured out, the majority of the artwork in this book was drawn without the use of a photo reference or model. How is this done, you want to know? It's simple. Practice. Draw what you see. Learn what to look for. Continue to practice. Then apply all the things you've learned and begin to invent your own portraits.

A lot of artists learn how to do this. What I'm showing you is not out of your reach.

I've attempted to give you a lot of information about the details of the head and features,

and rules and procedures that are commonly used. You will be required to know all of these things if you want to draw from your imagination.

## Practice, practice, practice!

I can't provide you with practice in this book, however. This is something you must do on your own! You must draw, draw, draw! Draw from photos. Draw your friends in class or at work (when time and opportunity allow). Draw family members. Sketch the people you see on television. Bring your drawing pad with you when you are waiting for the bus or plane and do quick sketches. Draw, draw, draw!

*"TV Cowboy" This is a sketch I drew while watching the TV. I didn't get a very good likeness of the actor, but it was excellent practice!*

Don't pressure yourself to try to draw imaginary faces too soon. A doodle now and then is perfectly fine, but you should devote most of your time at first to drawing faces from photos or from life. You want to have a solid understanding of *real* faces, before you start to make them up!

It isn't necessary to do a perfect likeness every time you do a practice drawing. What is important is that you observe the details of the face—how different noses, eyes, and mouths are shaded and shaped. How people's hairlines differ, how varied are the shapes of their skulls, and so on.

The human head is always fascinating! You will find that the more you draw and look at people, the more beauty you will see in all of humankind.

## Understanding the rules

All the rules of human proportion will eventually become second nature to you as you continue to practice. To further improve your drawing skills, study artistic anatomy books. Anatomy is not that difficult a subject to master as long as you set your own pace and are patient. Dedication and a true interest in anatomy will carry you far. (Check the Bibliography at the end of this book—I've listed my favorite anatomy books.)

**Learning how to shade your portraits**

Another key element to drawing convincing portraits without a model is knowing how the lighting on the head should look.

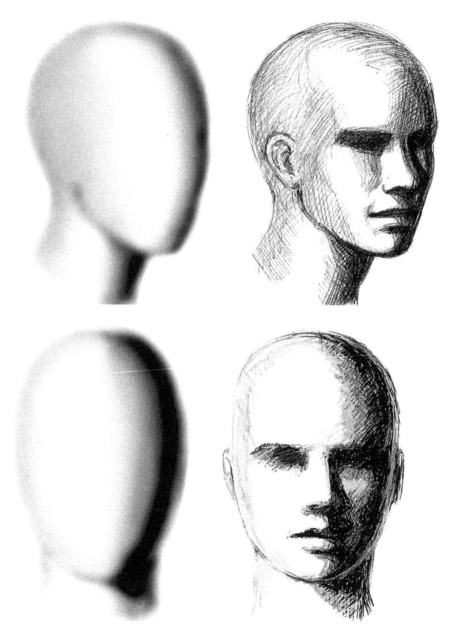

Here are a few simple examples of some different ways that the head may be lighted.

Review the shading tutorials in this book and also study on your own to see how light and shadow fall upon the face.

## Advanced shading exercises for drawing from the imagination

As you continue to practice, practice, practice, you will start to notice some common lighting patterns in the human head. Apply these lighting patterns to your own made-up faces.

An excellent way to learn how to create your own realistically-rendered faces is to study the lighting in existing pictures. Don't copy the photo—just take note of the lighting and try, to the best of your ability, to use the same lighting in your drawing.

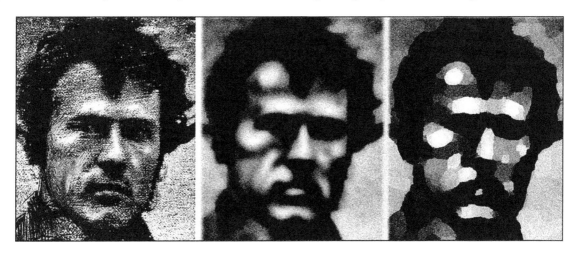

I found these fascinating public domain photographs in the Library of Congress's daguerreotype collection, which can be found when searching the site www.loc.gov. The photograph above is entitled "The earliest American extant portrait photo. 1839." The subject of this portrait is photographer Robert Cornelius. (Yes, this book is always eager to educate!)

I've broken down the lighting in Cornelius's portrait into simpler lights and darks. This is a rather unusual portrait—the subject has a furtive expression on his face and the lighting seems rather flat.

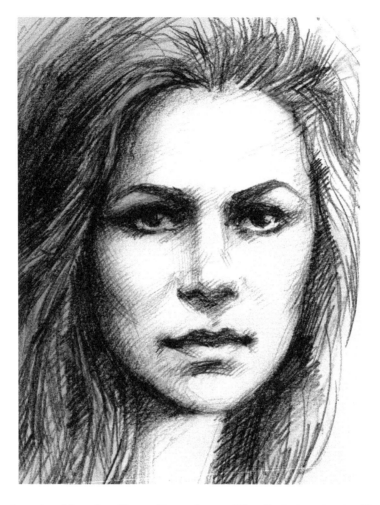

This drawing was inspired by the Cornelius photo. The lighting is similar (I did add more of a definite light source, on the right side) but the face is entirely different.

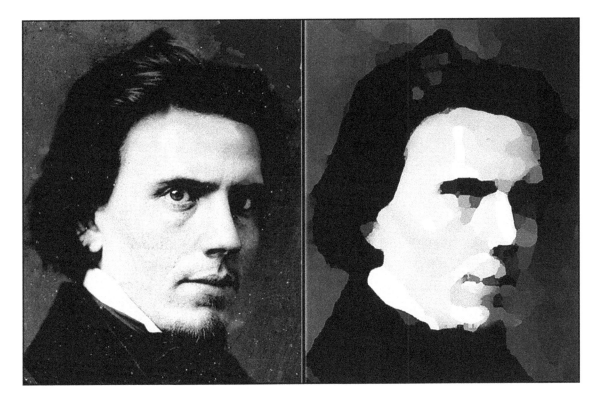

I like to call this photo "Intense Artist Guy," because I got the impression that the subject was an artist.

The lighting on this photo is far simpler: shadowed on the right side, light source hitting the left side. This lighting pattern is one of the easier ones to remember and imitate.

I drew a different type of face (and different sex) and applied the same lighting patterns as are seen in the Intense Artist Guy photo.

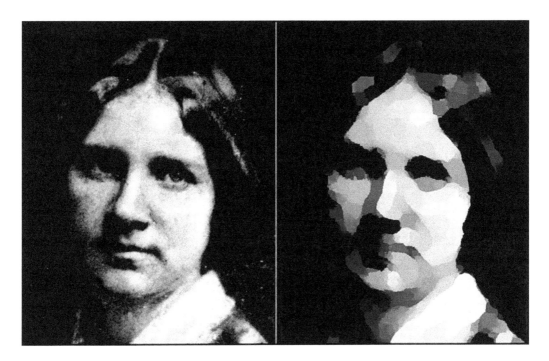

This is a portrait of the great Jenny Lind, a Swedish-born singer who gained popularity and fame in the 1800s.

The lighting on Jenny is a little more complicated than with the Intense Artist Guy, since the face is looking more toward the camera. However, the light source is clearly coming from one side.

Once again I took some liberties with the lighting to get the effect I wanted. Generally, the shading in this portrait is very similar to that in the Lind photo. The light source is coming from the right side of the picture. There are shadows under the nose and mouth and on the left cheek. The eye sockets are in partial shadow.

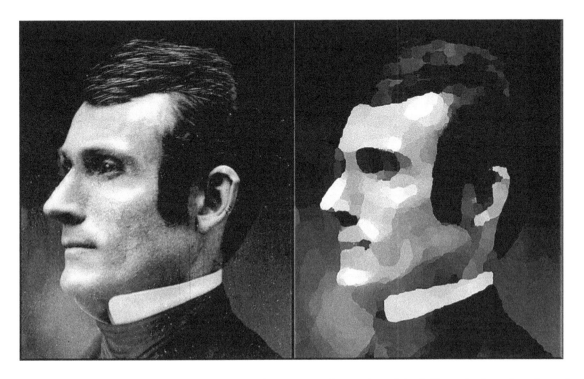

Ah—an interesting side view portrait. I have no idea who this fellow is, but he does look like an upstanding citizen.

Here is one possible way to interpret the lighting on the face in profile. The lighting on this face is also somewhat simple. There are typical highlights on the forehead, the bridge of the nose, and the "muzzle" area of the mouth and chin. The cheekbones are in partial shadow and there is a shadow underneath the jaw. The inner corner of the eye is in deeper shadow. This is not a complete profile view—a little bit of the other eye is barely showing. An interesting pose!

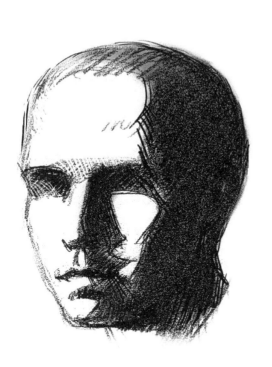
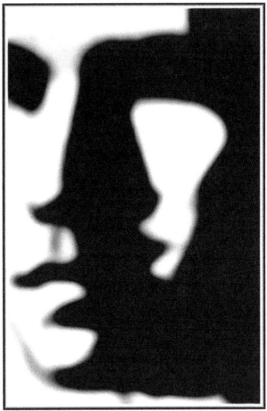

Take note of the unique negative shapes that form in various lighting situations. Try to be observant at all times and look at the way that lights and shadows fall across people's faces. Analyze why these shadows form certain shapes. Is the nose casting a shadow on the cheek? Or is it the mouth creating the shadow?

Continue to practice drawing faces from references. You cannot learn how to draw from your imagination unless you have spent many hours observing the real thing.

Bottom line, the best way to achieve the skill of drawing from your imagination is lots and lots (and lots!) of practice and observation. You've got to love drawing people.

You will probably find that after a while, you will become increasingly perceptive about the little details in people's faces. For instance, I tend to recognize heavily disguised people in movies, even when others around me notice nothing. (Hint: it's the teeth! An extremely disguised actor may be instantly recognizable because of their teeth. The teeth can be a dead giveaway.)

## Don't Do This!

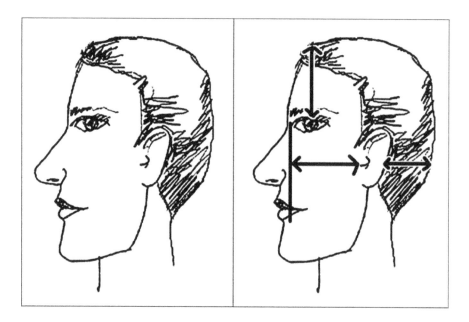

Here is a pitiful drawing, which shows many typical "beginner" mistakes. How many errors and pitfalls can you detect?

What a wretched way to draw a profile. Notice that the features on the front of the face are pretty flat.

The nostrils are placed at the edge of the face, which is not correct. The eye is an almond shape, which it should not be at side view. (It should be more of a triangle shape.)

There is not enough room between the front of the profile and the ear and there also is not enough room at the back of the head. (Not enough room for a brain!)

The height of the forehead is not enough—remember that the eyes are supposed to be halfway down the length of the head? It is, alas, too common for new portrait artists not to give their portraits enough forehead.

**Don't do this!**

This front view portrait is so horrible in so many ways.

Once again, there is not enough forehead. No room for the brain. The ears are too low on the head. The eyes are too big and too close together (less than an eye's width apart— that's too close). The nose is drawn with two harsh lines, as is the philtrum (the groove between the bottom of the middle of the nose and the top of the lips). There are severe "Howdy Doody" lines on each side of the mouth. The mouth itself is rendered with hard lines.

And the eyes—where does one start with the eyes?

The pupils are not completely round. The irises are not completely round. This, as you know, is completely unacceptable. To add insult to injury, the pupils are not concentric within the irises. It can't get much worse than that. The eyes are very noticeably crooked. Only Alfred E. Newman (of Mad Magazine fame) has such crooked eyes!

The eyebrows appear to be too close to the eyes. Very rarely does someone have eyebrows so close. The eyelashes are spiky and have that tarantula look.

The neck is far too narrow. This fellow has a pencil neck, indeed!

It isn't difficult to avoid many of these common mistakes. Measure your proportions, remember the details (like the iris and pupil being round) and check your drawing in the mirror to look for lopsided or irregular proportions. And most importantly, keep practicing!

# SECTION THREE:

# THE MANY FACETS TO BEING A PORTRAIT ARTIST—ARTICLES AND ESSAYS

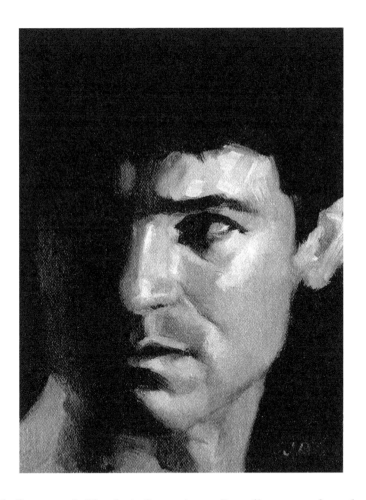

*"Fleeting Glance" oil on panel. Thanks to Jason Aaron Baca (jasonaaronbaca.deviantart.com) and photographer Portia Shao (positivevista.com) for the reference photo used.*

# CHAPTER TWELVE

# ADVICE FOR THE NEWBIE ARTIST

Not only should new artists work on practicing their drawing skills, they also should know some of the less tangible things about being an artist.

## Congratulations!

So, you are a newbie artist! Bravo! Since you have come this far, we know you have the courage to stick your neck out and learn a new and challenging skill. So pat yourself on the back and be proud of yourself. (And remember this feeling of pride when you are having an off day! You *will* have off days—we all do!)

When you are an artist, you are opening up a little bit of yourself (through your artwork) to other people. This can be a little scary at first, but don't worry. Just remember—you are not doing this for other people, but for yourself. So, while it's still understandable to care what others think, their opinions cannot matter more than your own.

### Nothing worth having . . .

Nothing worth having is going to be dropped on your lap. This applies to art, as it does to anything else. If drawing were such a breeze, everyone would be already doing it! Art is a fulfilling and fun activity, especially when you get started on the right foot with proper instruction. But it also requires patience, determination, and hard work.

## The myth of talent.

I can't keep repeating it enough—don't worry about talent. The concept of "talent" is very much overrated. Don't buy into this elusive, mysterious "talent" myth. I'm not saying that talent isn't a significant thing. But all art still requires practice and work. Many a mediocre talent has become an accomplished artist because they didn't give up. In contrast, many people with a strong aptitude in art do not go far with their ability—because they are not willing to push themselves. They believe that their "talent" is all they need, so they will not make any extra effort to improve.

## Are you too old?

There is no set age limit for starting to draw, as there are with other skills (for instance, ballet dancing or some professional sports). People of all ages and in different states of health have become successful artists. Individuals with serious handicaps have learned to draw and have sold their work.

Perhaps you feel insecure because "everyone younger than me is so much better." This is absolute nonsense. Almost everyone will admire you for taking on a new skill, no matter what your age. Think of people like ceramist Beatrice Wood, Sunday painter Winston Churchill, or painter Grandma Moses, who all started their artistic careers well into adulthood.

Many artists have gotten their start at a so-called "advanced" age. Trust me—it's been done already. So don't concern yourself about what anyone else is doing; just learn for yourself. You will one day marvel at how your drawings have developed and are appreciated by others. What a great feeling that will be!

## Don't get ahead of yourself

Don't think about selling your art or entering into art shows right away. Focus on developing your skills. But, to get an idea of what's out there, visit local art exhibits, art galleries, craft shows, etc., to see what other artists in your area are doing.

## Competition

Oh dear, it's something that plagues us all. But try to purge as many competitive thoughts from your mind as you can. They will only distract you and keep you from your goal, which is to be the best artist you can be.

Don't get me wrong—I understand that we are all competitive creatures. It's impossible for most of us to be completely oblivious to what our peers are doing. But so often, it is useless to spend too much time comparing. Each person comes from a different background and has different strengths. Some artists have a stronger sense of color, or line, or design. Some people draw animals better, or machines better, or whatever. See? It's all too complex! So, stop comparing yourself with anyone else!

If you join a class it might be difficult to refrain from comparing yourself with other students, but remind yourself that everyone is at a different stage of learning.

Make an effort to befriend anyone with whom you have feelings of rivalry. You'll often be surprised at how quickly feelings of competition can be squelched when you discover what a nice person your perceived "rival" is! (And even if they aren't so pleasant, you should always be comforted by the fact that you have been friendly instead of petty.)

## Criticism: How to take it

One of the toughest things to get used to is criticism. But if you create artwork and other people see it, you must become accustomed to getting feedback. Some of it is so painful to hear. It's especially tough when you are a beginner and you are not sure if this whole art thing is for you. But, please—tough it out. Getting criticism doesn't mean that you are a bad artist—it is just part of the process. Even the most brilliant artists get negative feedback once in a while. A lot of it can be very useful and helpful. You must be able to accept and listen to criticism. (But if you want to cry into your pillow later, that's fine. I give you permission!)

When someone gives you feedback that you find discouraging, please don't "shoot the messenger." You need to hear this stuff, even when you dread hearing it. It will help you become a better artist. You don't want to be oblivious to your weaknesses or flaws, do you? You certainly don't want to discover that people have been shaking their heads behind your back, lamenting, ". . . if only she'd make the noses smaller." The only way you'll learn about the areas in your work that need improvement is to listen to feedback! This is something that we all must endure unless we intend to keep our drawings hidden away forever, sight unseen.

There might be a few times, however, when you will encounter someone who is overzealous with criticism. You should not feel obligated to listen to an unrelenting and never-ending critic. Everyone should have limits to how much feedback they can digest at one time!

Even though I am encouraging you to listen to criticism, I do not wish you to think that you must be some sort of criticism sponge—forever soaking up negative comments and feedback. There will be some people who will go overboard and try to drown you with negativity. Try to avoid such people.

As you develop your artistic skills, you will be able to more clearly discern which critics are really trying to help you and which have another agenda in mind. Some non-productive critics may have latent feelings of jealousy or resentment. Others may love to hear the sound of their own voices and really don't have any credibility or knowledge. And unfortunately, there will always be those who will enjoy finding flaws in your work because it makes them feel clever and perceptive.

All artists have met such critics. While it is distressing to have to deal with such people, be comforted in the fact that it's not you with the problem, it's them. Learn to tune them out and go on with your work.

## Take a break once in a while

When you are practicing and drawing, make sure that you take a break once in a while. If you find that you are coming up against a brick wall, just put down your pencil and give yourself a breather. When you return to your artwork, you'll be refreshed, and may be able to quickly solve the problem that was previously plaguing you.

Don't overwork your art. Learn that there is a point when you are done. Don't keep picking and picking and picking at it. Sure, it's good to wait a few days, look at your drawing with fresh eyes, and correct a few errors, but there's a limit. Learn to let it go after a certain point. If you don't, you may end up ruining some very good artwork with endless fussing.

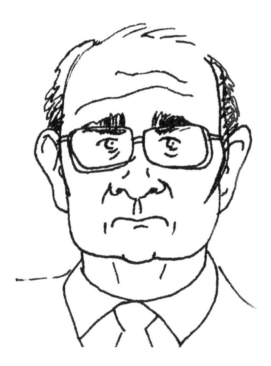

*Bubba—semi-cartoon from old sketchbook*

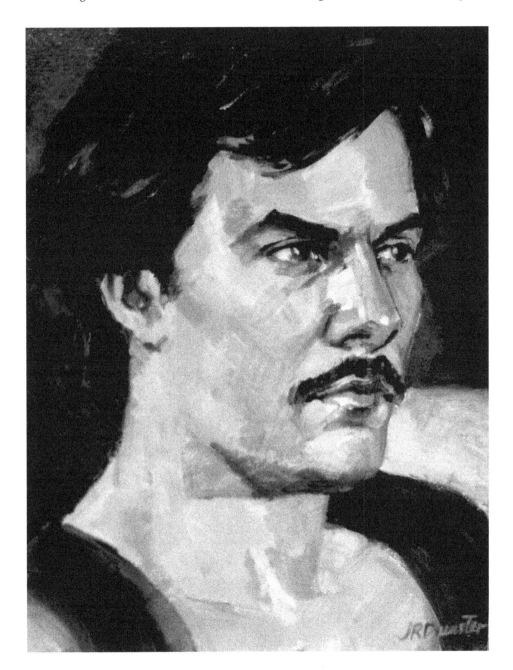

*"Bill," oil on stretched canvas. Painted from life.*

Drawing from life is a rewarding, fun thing to do, but is impossible to achieve without a solid drawing foundation. Which brings us to the next topic . . .

# Tracing and Other Drawing Aids

For as long as I can remember, a controversy exists when an artist traces over photographs rather than drawing "by hand."

We'll hear cries of, "That's cheating!" and some artists recoil in disgust and horror at the thought of tracing an image.

But, when we step back for a moment, that seems like an overreaction. There are no "rules" in art! There can be no sin in tracing over an outline of an image. In fact, undoubtedly it has been a handy and useful shortcut. So, it's not tracing that is bad. The circumstances in which it may be used could be the source of the problem.

## Being evasive

I believe that there is an ingrained instinct in many of us to dislike someone who is passing themselves off as something they're not. Even if it's not intentional, this is what *some* artists seem to be doing. They conceal their creative process and allow everybody to think that they drew everything freehand, even though they don't possess a solid drawing skill.

Some will make the argument that it's nobody's business how an artist does their work. That is true. But, let's be honest. Few people assume that artists can't draw. Drawing is one of the first things we are expected to learn. It is a cornerstone of the whole artistic process. It is natural for most to believe that a representational drawing or painting was created freehand.

So, when an artist tries to hide their lack of drawing skill by tracing (but never letting anyone know that they do it), they may receive credit for a skill that they haven't worked to cultivate.

Obviously, this can rub others (artists and non-artists) the wrong way. It's not that the tracing is so bad. It's just a method. It's when the artist keeps it a secret, for fear that they'll lose some respect.

It is much better when they are honest about it. If they have nice artwork, we will probably decide that we don't care if they trace, because we like the other qualities of their work. But—when they are evasive and appear to take credit for a drawing skill that they don't have, they are at the most risk of losing the respect of others.

Again, the most important thing is to be honest. Whatever you do, be open about it and hold your head up high.

But, with that said, I don't encourage that artists start tracing, because drawing offers many benefits and advantages.

Later in this book I preach about the virtues of working from life. By that I mean, having a model pose for you.

The camera has limitations. Our eyes see so much more than the camera can capture. We see more colors, we see a richer range of lights and darks. The camera can distort lines and perspective. But, when we can draw or paint from life, we will capture life as it *really* looks.

If an artist is dependent on tracing over photographs due to a lack of drawing skill, then they are cutting themselves off from the experience of working from life. Their art can suffer because of it.

**For accuracy's sake**

I sometimes hear artists say that they use a projector to "get accuracy." But I wonder about that. If an artist is unable to get accuracy through their freehand drawing, then how is tracing going to help? They are relying on a device to compensate for a skill that they lack (accuracy), instead of working to improve the skill itself.

Other artists justify tracing photographs because it speeds up the process. This is understandable. The great illustrator Norman Rockwell was known for using a projector-type device to meet his strict deadlines. But, Norman Rockwell had excellent training and was an amazing draughtsman. He could prove this at a moment's notice. His deadlines must have been brutal and often his paintings had complex compositions, and this is why

he used a projector. How many current artists are working under similar conditions? Many busy illustrators are, but the rest of us? No.

## Important reasons to improve your drawing skills

In the last few years I've been seeing more and more amazing artists whose paintings have gorgeous color. Their artwork looks so natural and so much richer than anything a photo can capture.

These artists share one characteristic. They all work from life as much as possible. That is why they are able to paint such beautiful color!

Some artists and art connoisseurs have an exceptionally sharp eye. They can tell when a painting is done by an artist who works primarily from photos, versus an artist who also works from life. Apparently the values are more flattened (especially in the deep shadows and highlights) in the paintings of artists who mainly work from photos.

I'm not that perceptive yet! I can't "tell" when someone works only from photos, but I can spot the paintings which show especially gorgeous color. The common denominator seems to be that those artists work a lot from life.

These same artists frequently offer classes and workshops across the country, and sometimes if you catch an artist earlier in their career, their lessons are quite affordable. But, to benefit from their teaching, obviously you need to be able to work from life, which means freehand drawing.

In recent years I've been able to spend more time studying from life, and my artwork has improved a hundredfold. I still have a way to go, but it has made a *huge* difference.

# Attitudes and Self-Esteem

What should an artist's attitude be?

Your attitude should be love, enthusiasm, passion, and dedication. You have to love what you're doing, or else you won't last very long. You must love your art enough to weather the tough days.

You can't keep your interest in art alive by thinking about how much money you'll make, or how much praise or attention you'll get because of your abilities. You may not always experience these things, or may not get them when you think you are entitled to them. Instead, be sustained by the progress you see in your drawings and by the knowledge that your efforts will be rewarded with steady improvement.

## Self-esteem

Self-esteem is when you have faith in yourself and in your goals and dreams. You should realize that you are one of a kind and that you have the potential to excel, in your own unique, special way.

While having self-esteem is a necessity, you shouldn't assume that whatever flows from your talented fingers will automatically be brilliant. It rarely works this way. You need to steadfastly believe in yourself, while always realizing that there is room for improvement.

If, however, you suffer from too little self-esteem, if you are too afraid to stick your neck out and try, if you are convinced you will fail, how far can you go in developing your talent? Reject any thoughts of failure; counter them with the knowledge that practicing a skill, done with diligence and determination, will eventually result in improvement.

## Everyone is different

Yes, I guess each of us are special snowflakes after all. There are no two artists who are alike in the way they express their creativity. Work to recognize your own specific artistic strengths (while striving to improve your weak areas) and you will always have reason to feel pride in yourself and your art.

## Are you too old or too young?

Well, you should already know the answer to this question. No, of course you can't be too old or too young to learn how to draw!

## Is there such a thing as "too young"?

Absolutely not. Art should be encouraged and cultivated in any young person.

I felt a deep interest in art as early as age four. I always had doodle paper with me wherever I went. A sincere interest in art should never be postponed or squelched, no matter what the age.

## You're never too old to start

I have witnessed older people ("older" being a relative term) introduce themselves to drawing and art with great results. They loved art, they were passionate and dedicated, and it showed in all their efforts.

Many art classes (especially community or night classes) are full of older people. Some take up art after they retire. Others find the time after their kids have grown and are more independent. There's nothing unusual about people who are well into adulthood introducing themselves to art.

Everyone, no matter what their age, should be actively learning new things and finding

ways to expand their world. It will keep them excited with life.

## Don't let pride get in your way

Some people let their false pride keep them back. They are worried that they will look foolish or that everyone else in art class will be younger than them. This is a terribly shortsighted viewpoint and will only lead to regrets later on.

## What have you got to lose by trying?

Years ago, one of my dad's friends discovered that he had an aptitude for art. This fellow already had a nice, secure job and a family to care for. He spent long weekends going on location to paint and he truly loved it. But he was unsure whether art was really for him since he started at (what he thought was) an advanced age (late 20s or early 30s).

With encouragement from his family and friends (like my dad), this fellow finally decided that art was to be his destiny. After a while he was even able to quit his stable job and become a fulltime artist.

This man was Ben Abril and he became quite a successful artist in the Los Angeles area. Imagine how different and how much less joyful his life would have been had he decided that he was too old to follow his dreams to be an artist!

You don't want to be one of these wistful, unhappy people who lament that they "could have" or "should have" done something, do you? None of us are getting any younger. Where will you be in 5 or 10 years? Do you want to have several years of drawing experience behind you at that time, or do you want to be talking about what you *could have* done?

*Lucinda Couldn't Figure Out What Her Husband Was Doing with All Those Sponges — semi-cartoon from old sketchbook*

*His Name Is Ned—semi-cartoon from old sketchbook*

# Snobs and Cretins

Some of us are too hasty to label others with the title "snob" or "cretin" (meaning a person with lower-class tastes or sensibilities).

## All people are entitled to an opinion

Some opinions are more informed than others. People may discover that after they've been exposed to some art education, paintings that they originally considered to be pretty bad all of a sudden start looking pretty good. They begin to understand the history behind the painting, and are able to appreciate different styles of artwork.

It is so much easier these days to be exposed to many styles of artwork from a variety of cultures. With the Internet and so many outlets for sharing information, many forms of art can be readily available.

Everyone will have distinct tastes, based on their personality or cultural or family background. They may have strong emotional ties to certain things. It won't matter to them that some factions of society might consider some of these personal tastes to be "common". They enjoy them, they have their opinion, and that's the end of it as far as they are concerned.

## Pigeonholing others

While it may be human nature to label those whose opinions differ from your own, it is not wise to be hasty in passing judgment. If somebody refuses to see things your way, are they being rude about it? Are they insulting your point of view, or are they just sticking to their own opinions?

Is a person really an ignorant cretin if they are enthusiastic and passionate about a form of art, even if they are relatively uneducated about it? Are they somehow inferior compared to an educated person who is well-versed in artistic culture, but has no real

love or passion for any of it?

And, what about people (usually art enthusiasts or artists) who are so firm in their personal tastes that they are painfully inflexible? They *know* what they know and what they enjoy and there is no discussion or debating with them on the matter. Are they snobs? Or just people who have decided opinions and aren't afraid to hold firm to them?

## Dissenting opinions and how to deal with them

The bottom line is that we all should be civil and respectful instead of being insulting or ungracious. There is room in this world for many different tastes and sensibilities.

When we encounter dissenting opinions, we should strive to not become distressed or offended. We should have confidence in our own opinions and not worry how others label us.

*William Can't Decide Whether He Should Go with the Military Look or the Elvis Look. — semi-cartoon from old sketchbook*

# We Draw Ourselves

An interesting phenomenon among artists is our unconscious tendency to draw ourselves, or rather, to be more comfortable or adept at drawing people with our own physical characteristics. When we draw a person who does not share some of our qualities, we often will make our drawing look a little like us anyway, even though such a similarity does not exist in the model.

Beginning life drawing students sometimes have trouble drawing the opposite sex accurately. For example, I used to draw the male body with wide, feminine hips. To me, the male figure always seemed much more difficult to draw, but I saw that some male students in class had the opposite problem—they had trouble drawing the female form. Their drawings of women were stocky and too masculine.

We are more used to seeing our own faces in the mirror, so we might also draw people that look a little bit like us as well. For instance, if an artist has a short nose and a wide mouth, they might tend to make anyone they draw have shorter noses and wider mouths. Artists do this unconsciously—they certainly don't mean it—but it creeps up in much of what they draw. It takes some effort to overcome this tendency.

This is not to say that we must purge all of "ourselves" from our drawings. We are all individuals and we should never try to squelch our unique qualities. We just need to be aware of this tendency and not allow it to get in the way of drawing an accurate likeness.

*Emma Snell Doesn't Approve of Any Colors, except for shades of Beige—semi-cartoon from yet another old sketchbook*

*"Elf Man," ink. From an old sketchbook*

## Accept the Fact

There are certain things all artists (especially portrait artists) have to accept. They happen to all of us; you are not alone.

### Accept the fact that some of your artwork will suck bilge water

You'll have a sketchbook full of drawings. Some of them will look great. Others will suck bilge water so bad. You will not understand how you could produce them! But there they are, taunting you with their ugliness.

Accept this. You are destined to produce an awful piece of artwork now and then. Take heart—the more you practice, the less often it'll happen. But don't assume that you'll ever be fully exempt from this trauma—sadly, it doesn't work that way. Even highly skilled and expert artists are capable of making dreadful art.

### Accept the fact that not everyone will understand your work

It's not always your fault. When you show your work at the wrong time or to the wrong audience, you may get a disappointing or downright discouraging reaction. Always remember that not everyone will recognize or appreciate artwork if the subject of the art holds no interest for them. For instance, if you were to do a portrait of a famous opera star and show it to some heavy metal rock fans, their response might be unenthusiastic. However, show the same portrait to an opera fan, and the response could be excitement and admiration.

### Accept the fact that there will be better artists than you

If you are one of those people who must be the best in the class, then give up now. There will always be someone better than you out there.

"Better" is an emotionally loaded word anyway. Ideally, it should mean a more advanced

understanding of certain disciplines and skills and nothing more. Or it can mean an aptitude in a specific area. But "better" is also a matter of taste and opinion.

## Accept the fact that you will produce something really goofy now and then

Art is not for the extremely proud, who cannot bear to do something stupid and idiotic. All artists will humiliate themselves sometimes. Don't worry about it too long. Just keep plugging away at your work, comforted in the fact that everyone on earth has disgraced themselves, and will continue to do so.

## Accept the fact that things don't always make sense

It's as simple as that. You won't sell a portrait that you hoped to sell. People don't like a drawing that you know is skillfully rendered. Your least favorite drawing is the one that everyone else prefers. Someone else gets an art award and yet you see no appeal in their work. Whatever it is, it doesn't make sense. But it happens. Accept it.

## Accept the fact that sometimes life gets in the way and you can't keep to your artistic timetable

If you can't draw as much as you'd like, sometimes it just can't be helped. Perhaps you have family obligations or job or school commitments, and sometimes they just suck up all the time. Try to squeeze in a little art time when you can, but don't become too stressed out. You may even have dry spells that last for prolonged periods of time. It happens. It doesn't mean that you'll start from the beginning when you return to art. Just do your best and find the time when possible. Continue to observe life, people, and all the things around you. Keep your dream alive. Borrow art books from the library and expose yourself to a variety of art styles.

However, never accept that frittering away time on other recreation cannot be avoided. Decide that your art is more important than some of these other things. If you do prefer

a meaningless recreation over your art, don't ever complain about how you don't have time to draw. It won't be the truth.

## Accept the fact that sometimes the best things just fall on your lap

Sometimes you work and sweat for every break you get, but sometimes it just *happens*. Don't be too amazed and astonished when something really insanely great happens to you without notice. However, don't spend too much energy expecting certain results from your hard work. Just remain busy and active. Stop expecting anything and prepare to be amazed when things start happening!

Enter into any situation (art show, competition, etc.) with few expectations. Tell yourself that if you don't have any success this time, it's okay. Do your work for its own sake— for the good feeling it gives you. Always strive for your own personal excellence.

However, even though it's wise not to assume that you're especially "entitled" to successes or recognition, that doesn't mean you shouldn't have any ambition. It's okay to enter an art show or competition with the thought that something great *could* happen, and so you must try!

## Accept the reality that dedication and excellence will always pay off

Would you prefer to be a no-talent hack who makes lots of money or an extremely good (but yet unknown) artist who is truly passionate and excited about creating art? True excellence has rewards that the no-talent hacks can never experience. Accomplishment and a genuine skill have unlimited potential.

Have faith in yourself and have hopes for your future. It may sound artsy-fartsy or crackpot to some, but many artists believe in a spiritual law that says when you have faith and never give up, your heart's desire will come to you.

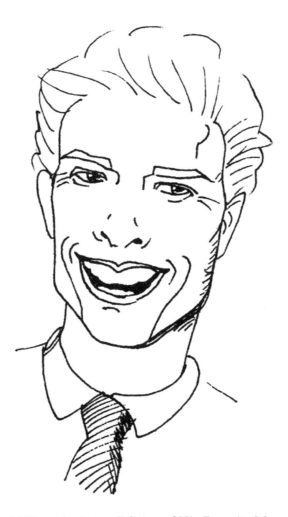

*Lance Is Always Very Elated When the Latest Edition of His Favorite Magazine, "Macintosh User,"*
*Arrives in the Mail—semi-cartoon from old sketchbook*

## Artistic Angst

Being an artist is a fantastic, wonderful thing that can forever enrich your life. But sometimes there's angst. Some of it comes from yourself, while some of it is a contribution from those around you.

Art can be a rather solitary activity. But artists, by our very nature, want attention and approval. When we don't get it, or don't get it in the way that we'd prefer it, angst can happen.

I learned a very important lesson when I was about age 14. It is a tale that I now relay with affection and amusement, but believe me—at the time it was High Drama.

I had always been keenly interested in art, but starting at about age 12 I became even more serious. My mom, for reasons too peculiar to explain here, was concerned about my obsession with art and tried at every turn to discourage me from it. This caused me great confusion and distress, because my mom was otherwise a loving and supportive parent.

One day I decided (in a moment befitting the greatest of martyrs) that I would Give Up Art Forever. With great fanfare, I took all my art supplies out to the garage to put them away. My mom happened to be doing something in the garage at the same time.

I made a great production of putting my art supplies in a box, to be forsaken forever by poor little misunderstood me. I looked over at my mom, who was busy with something else and not really paying attention. It then hit me: if I gave up art, no one would really notice. My mom would probably be relieved. The rest of the family would be puzzled for a while, but they were all very busy with their own little internal melodramas and they'd soon forget all about my Great Sacrifice.

With that realization, I quietly unpacked all my art stuff and took it back inside. I never again felt the need to give up my art. Oh, I won't say that all my teenage angst ceased from that time on, or that my mom magically started to comprehend how important art was to me. (She came around a while later, though.) But after that day I didn't worry and fret so much about what other people were thinking. And I knew that I'd never give up something that meant so much to me, just because *other* people were giving me grief.

When you give up on something that you love, the one that you hurt most is yourself. Don't expect anyone around you to care. It's possible that they might care—but they might not. And even if they do care, they can't possibly be impacted as much as you will be.

We all live in our own little universe. Don't expect everyone to be paying attention to what is happening in your world. Remember that you may not be always aware of what is going on in their world either!

*"Santa from the Valley" From an old sketchbook*

*"Beehive," from an old sketchbook*

# Copyright issues and artists' rights

Many people are woefully ignorant of the fact that they own many rights to their intellectual property. Intellectual property is usually defined as creative or unique works, like artwork, photography, writing, and music.

I strongly encourage any artist, newbie or otherwise, to educate themselves about their rights. Too many artists are still not aware that they actually own the copyright to their artwork. This ignorance makes it easier for unscrupulous people to take advantage of them.

Copyright information can be confirmed and researched on the Internet and everyone who reads this chapter is urged to also consult other sources for information about copyright in order to further educate themselves. This chapter does not claim to give any official legal advice.

It is only possible to discuss a fraction of artists' rights and related copyright issues here. If you have a copyright question or concern, please visit your country's copyright Website for more detailed information or consult an attorney who specializes in copyright.

## What are the artist's rights and who is entitled to copyright?

The U.S. government's Website on copyright (www.copyright.gov) states:

> Copyright protection subsists from the time the work is created in fixed form. The copyright in the work of authorship immediately becomes the property of the author who created the work. Only the author or those deriving their rights through the author can rightfully claim copyright.

Please take special note of this: *the work immediately becomes the property of the author who created the work.*

This is interpreted to mean that as soon as you create some artwork, you own its copyright. You don't have to write "Copyright" or a special © sign on your artwork (though it is a good idea), you don't have to register it with the Copyright Office (though

there are advantages to doing this), *you don't have to do anything*—as long as you made it, the copyright is yours. The copyright to your artwork instantly and automatically belongs to you if you live in the United States or in any of the many other countries that have similar copyright standards. This copyright is yours throughout your life and usually will be passed onto your heirs for a number of years after your death. (Check your country's copyright laws to get more specific information.)

More information from www.copyright.gov:

> Mere ownership of a book, manuscript, painting, or any other copy or phonorecord does not give the possessor the copyright. The law provides that transfer of ownership of any material object that embodies a protected work does not of itself convey any rights in the copyright.

This means that if you sell your artwork to somebody, you are not automatically selling your copyright along with it. You must specifically consent to sell or give away your copyright. If someone buys a drawing of yours and you don't agree to also sell them publishing rights, they don't own those rights. They are not legally allowed to publish your artwork. They have merely bought the original drawing to display in their house or elsewhere.

Some clients may buy limited rights, which means that they are buying the right to publish the drawing for a specific or limited use. They may want to use the drawing for one issue of a magazine. Or they need it for a series of magazine ads that will run for only one year. If they want to buy these rights, you will discuss this before any money (or artwork) changes hands.

It is not at all uncommon for a client to buy publishing rights (limited or otherwise) and yet not buy the original artwork. This means that you give them permission to publish your artwork but you still keep the original artwork yourself. If they want the artwork and publishing rights, they must pay for both.

Sometimes, artists are asked to work under a work for hire contract. This means that they

are paid a certain fee or wage and their client or employer automatically owns all rights to the artwork that they have been hired to create. An artist will always have to sign a contract of some kind to do work for hire. Many artists and other creative folk are reluctant to sign work for hire contracts because they don't think that they will get a fair shake in the deal.

**Fair use and copyright**

Fair use can be difficult to define and is usually judged on a case-by-case basis. Fair use generally means that other people can use your intellectual property (and you can use theirs) without permission under certain circumstances.

The U.S. Copyright Office has this to say about fair use:

Section 107 contains a list of the various purposes for which the reproduction of a particular work may be considered "fair," such as criticism, comment, news reporting, teaching, scholarship, and research. Section 107 also sets out four factors to be considered in determining whether or not a particular use is fair:

1. the purpose and character of the use, including whether such use is of commercial nature or is for nonprofit educational purposes;

2. the nature of the copyrighted work;

3. and substantiality of the portion used in relation to the copyrighted work as a whole; and

4. the effect of the use upon the potential market for or value of the copyrighted work.

The distinction between "fair use" and infringement may be unclear and not easily defined. There is no specific number of words, lines, or notes that may safely be taken without permission. Acknowledging the source of the copyrighted material does not substitute for obtaining permission.

## Beware of anyone who says, "But it'll be good *exposure* for your art!"

Many new artists are so thrilled and amazed when someone wants to use their work that they don't worry about asserting their rights. It's understandable for a new artist to want to give away their art in the beginning, just so that it will be published and seen by others. If they want to do this, they should still be aware that they are always entitled to certain rights.

Many times a group of creative people will get together to work on a project. No one is getting paid; they are doing all the work for the love and the enjoyment of creating. Such arrangements can be a wonderful learning experience and may benefit everyone involved. Other times, an artist will decide to offer to do some free work just for the fun of it. There is absolutely nothing wrong with offering freebies and most artists will do this from time to time.

It's okay to occasionally work for free on a fun project with the full knowledge that there may not be any compensation. However, be warned that many artists have been exploited by greedy or cheap people looking for freebies. Such unscrupulous people will feed the eager artist a line such as, "We can't pay you now, but we'll pay you if we make any money on this project. But even if we can't pay you, working for us will be good *exposure* for your artwork! We're doing you a favor!"

Be very wary of such offers. Usually the artist never sees any money for their work. Other people working on the project get paid, but not the artist.  The promised exposure may never happen or might be very disappointing. Often the "client" merely wanted to get something for nothing.

"But it will be good *exposure* for your artwork!" is a very old and tired line. Ask any artist who has been creating work for more than a few years and they will probably tell you a tale or two about their experiences with this worn-out pitch.

Of course, there will always be truly legitimate deals that will benefit the artist and will give the artist worthwhile exposure and experience. Therefore, a new artist should not be too cynical or suspicious. Just be aware that there are many people who are willing to

take advantage of your ignorance. If you decide to work on a project promising exposure but no other compensation, proceed with caution.

**"Art wants to be free!"**

Well, no, it doesn't. At least not according to most artists.

"Art wants to be free" is another old, tired line. (As are similar lines like, "If you expect to get money for your art, you have cheapened yourself and your art and therefore you are not a real artist.")

Some people who don't respect the copyrights of others will use phrases like "art wants to be free" and "art wants to be shared." A few even believe that the artist should have no say or right over where their art is published or how it is used. They may also rationalize, "Well, the artist will make the artwork anyway, because they enjoy doing it. So why do they expect to get paid as well?"

This is outrageously insulting to most creative people. Artists need to make a living just like everyone else. They have worked hard to perfect their skill, often spending years practicing and studying. Since artists put so much effort and time into their work, they feel like they should have a say over the ways that their work is used.

Some people apparently don't want to acknowledge the fact that if artists did not have rights over their own work, many would severely limit what they released to the public. If copyright laws did not exist, anyone could copy any artwork at any time and do whatever they pleased with it. If such a thing were allowed to happen, imagine the consequences. A deeply religious person might see their art used in a morally offensive way. A struggling artist might witness their hard work being used by a large company and helping the company earn big profits, while the artist made nothing from the work. How many creative people would want to publish their work or put it on display if such conditions were allowed to exist?

Fortunately, it does not appear that copyrights are going away anytime soon. Since some

people are willing to take advantage of artists, be careful and keep yourself informed of your legal rights—it is your best defense.

## Your responsibility to honor others' rights

Many artists who are ignorant of their own rights to copyright are equally ignorant of their responsibility to honor others' copyrights.

It is common for artists to use photographs for reference when they create their art, but they must be careful not to violate the photographers' (or other artists') rights when they do this. After all, photographers do not want their art to be free either!

There are theories floating around about how much of somebody else's work can be copied and yet not be a copyright violation. Some people say that if you copy 15% of a photo but no more, you're okay. Others say that it's 30% or less that is acceptable to copy. Then there are others who claim that even a little copying is not acceptable. It's a confusing issue and I cannot say that I have a definitive answer to it.

Many artists get around the whole "How much is okay to copy?" issue by being their own photographers and only using photos that they take themselves. This is the safest route—they are also the copyright holders to the photographs that they are using as a reference, so there is no risk of copyright violation.

No doubt, if you ask 20 different artists for their opinion you will very likely get 20 different answers. Add into the mix the popular phenomenon of fan art (fans of movies and TV shows creating art from these shows) and there is too much complexity in this issue to discuss without making this chapter an unreasonable length!

It is not uncommon for art students to copy photographs or artwork that they find in magazines or books for practice work. I have never heard of a student getting into any legal hot water over such copying, as long as they did not profit from their practice works or in some way take away sales from the copyright holder. However, I will emphasize— I am not a lawyer, and am not offering any legal insights here. Use your common sense

when copying others' works for practice.

Do your own individual research on this subject and put some thought into how much copying you feel is appropriate for you to do. Be especially thoughtful and careful if you intend to sell prints or otherwise profit from any of the work that has a copied element in it. Remember how you would like your rights to be respected and try to always respect others' rights as well.

## Using stock photography and networking with photographers

Thanks to the Internet, artists can find photographers who are willing—no, more like excited—to let their photos be used as drawing or painting reference. This is a wonderful resource! You'll notice that in this book, I sometimes credit someone else's photo as reference for a painting or drawing.

Using stock photos can be an agreeable arrangement for all involved. The photographer enjoys seeing what artists do with their photos. The artist has access to reference images that they might not be able to take on their own.

There are a number of places where you can find stock photos. One of my favorites is deviantart.com. (Search in their stock photography section.)

Whenever you find stock photos which could be used for reference, make sure to confirm that the photo *does* belong to the photographer. Verify that you will be able to fulfill all the photographer's terms. Do they require that you link to their website when you post your artwork? Make sure you honor that request. Do they forbid that you use your artwork for commercial use? You must do that as well.

Even though I have enjoyed using stock photos from time to time, I don't think it's a good idea to rely on them too often. It's always best to use your own photos (or better, work from life!).

*"Guitar Players," drawn from life, from an old sketchbook*

## Art Is Worthwhile

There's something especially worthwhile about being a portrait artist. Portrait art can capture a likeness better than some photographs. It can bring back bittersweet memories of a lost loved one, or capture a moment in time that is forever precious. There is a living element to art that is hard to measure.

Some of you may have been raised in an environment that did not appear to value art very much. Or you might be surrounded by people who believe that art is something that you can only allow yourself to do after you've got the really important stuff done.

That's a wrong way to think. Art is important. Think what the world would be like if all forms of art—music, creative writing, design, art, film, anything creative—were taken away. We would live drab, horrible, almost unlivable lives.

If you have the passion to be an artist, it should be an important priority in your life. I'm not suggesting that you neglect your crying baby or not get the car fixed because you'd rather work on your art. I just want you to know that it is okay to take yourself and your dreams of art seriously. You deserve to cultivate this dream. It's not a silly or frivolous aspiration.

You may have been told that you'll starve as an artist, and I won't deny it—many people can't afford to be fulltime artists—at least not at first. (However, portrait art does seem to have a fair amount of earning potential since people love to have their portraits painted!)

Even when there is no great hope of raking in the money, art is still a worthwhile activity. (But, with that said, many successful artists don't agree with the "starving artist" myth. They tell us that they persevered until they found success, while the "starving artist" lost hope and gave up too soon.)

To follow your dreams, to not have regrets, to not have to say, "I could have, I should have" in five, ten, or twenty years—that's a worthy goal. Seeing a talent and potential that was buried inside of you be uncovered and cultivated—that's something worth striving for. Developing healthy self-esteem because you never gave up and achieved

your goal—that certainly is of value. And seeing how others respond and appreciate the unique, one-of-a-kind art that you were able to create—that's one of the greatest feelings of all.

A passion for art has enriched many people's lives. Troubled teenagers have found that art was their only escape, their only source of solace and joy during a particularly painful time in their life. Many retired people have discovered that life can be more fulfilling and exciting than ever, all because of art. Elderly people keep their minds sharp and active through the cultivation of a new skill. People with handicaps can reach out to the world and express their creativity through drawing and painting. Art is a beautiful, enriching thing. It is fulfilling to those who create it; it feeds the souls of those who admire it. It is certainly worthwhile.

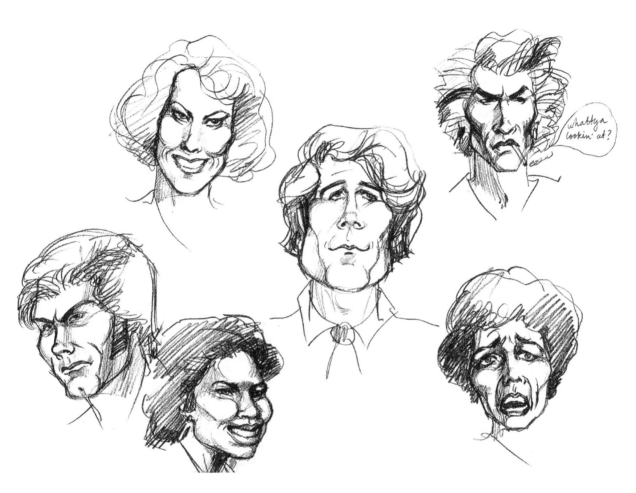

*"Random People" from an old sketchbook*

# CHAPTER THIRTEEN

# OTHER GOODIES EVERY NEW ARTIST SHOULD LEARN

## What's so great about working from life, and why you should do it

Art students are often told to "draw from life." Working from life is defined as looking at an object placed in front of you and drawing it as you see it. You are not looking at a photograph and copying it, instead you are drawing the real thing.

This practice is encouraged for a reason. Partly it's because students should know how to draw what they actually see. The only way to learn what real life looks like is to observe and draw what's in front of you.

Working from life is also preferred because cameras can change and distort objects in small but significant ways. When you only copy photos, you are one step removed from your subject. The camera made its own interpretation of the model. You are then copying what the camera shows you. By working from life, you are eliminating the 'middle man' (the camera). This results in a more genuine and accurate depiction of the subject you are drawing.

### Drawing from life versus drawing from photos

I drew a lot of portraits from photos, starting when I was a young teenager. I'd draw my favorite actors and actresses, like a lot of kids do. I occasionally drew from life (my friends would pose for me) but most of the time, I copied photos.

When I first took a Life Drawing class (drawing the figure) in college, it

was extremely difficult. I struggled terribly with my drawings, which was mortifying! I had always assumed that I drew pretty well, because I was doing a decent job of it with photos. But I had such a long way to go in developing my drawing skills.

Copying a 2-D thing (photo) into another 2-D thing (your drawing) is a far cry from looking at a 3-D person and converting that to 2-D. Plus, 3-D "life" is different than photos—photos change color a little bit, flatten tone, and sometimes warp perspective. (Ever see how much distortion a fish-eye lens does? Well, all cameras distort a little bit—just not as noticeably as the fish-eye lens.)

I didn't fully comprehend the differences between life and photos until I was able to make a direct comparison. I sometimes attend a painting group where several artists gather together on a regular basis to share a model. We only have a few hours to paint this person from life. If we can't finish our painting, we take our own photos of the model for reference, and complete our work later in our studios.

I found that when I was painting the model sitting in front of me, I saw a rich variety of values in their face. There was detail in the deepest of shadows. The highlights were subtle and there was much to capture there too.

To my dismay, I found that my photo of the model lost most of the detail in the lights and darks. The darkest values were converted to black. The lightest highlights became white. The photo fell short of capturing what I was painting! Not only that, the colors were often wrong too. The photograph wasn't nearly as rich or as interesting as what I remembered when I was looking at the model in real life.

When some artists talk about the importance of working from life, they aren't exaggerating. There *can* be a big difference. You do yourself a disservice if you deprive yourself of the experience of observing life and drawing it as it is right in front of you.

If all you're used to doing is copying photos, then adapting to drawing from life can take some time. But, it's worth the effort. Don't be discouraged if at first you struggle. So did I! Keep on practicing. You'll find that you will improve soon enough.

A steady diet of working from life increases your skill and helps you understand *what* you are drawing, as it's right there in front of you (not just some shadows and shapes in a

photo). In addition, drawing from life, where you have some pressure to complete the drawing before the model's pose is finished, helps you increase your drawing speed and become more decisive.

I'm not saying that copying photos is bad. I still do plenty of it myself. It's just not a good idea to *only* copy photos. If all you ever use are photo references, it's possible that some of the distortions and errors that photography contains will be integrated into your artwork, without you even realizing it!

*"Bill," drawn from life*

222

## Working from life creates priceless memories

There are technical reasons why working from life is worthwhile. But that's not where it ends. When you have a model sit for you, you are creating an *experience*.

My sketchbooks contain many portraits of various friends who posed for me. Almost without exception, I can remember the day when I drew the portrait. I recall our conversation. I can look back and remember whether it was morning or evening. Sometimes I even know if it was a sunny or a rainy day.

I *connected* with the model in some way when working on their portrait. In this little sketch of Bill (previous page), I remember where we were when Bill posed for me. I have some vague recollection of what the room looked like. Years later, I still have this vision in my mind of those moments when I did that particular drawing.

For most of the sketches I've done from life, there is an equally indelible imprint on my brain of the time spent working on the portrait. Drawing from life becomes an *experience*, instead of only an exercise and a display of discipline and skill.

Another unique thing about working from life is that we are able to express our emotions and feelings about the person we are drawing. Our portrait will show this, for everyone to see.

We don't capture the model's likeness in our artwork in the same way that a camera captures light and dark. A camera depicts every wrinkle and flaw. It has no discrimination. We don't do that when we draw or paint a portrait—we see the model's liveliness, their wisdom, their beauty. We filter out the unimportant stuff (like a few gray hairs or some blemishes). Portraits from life will more accurately depict what we "see" in each other, as fellow human beings.

*"The Head," portrait of a plaster cast. Painted from life. Oil on panel.*

# The "De-skilling" in Formal Art Education, and Why that's a Problem

A popular page on the portrait-artist.org site is about seeking a formal education. The conclusion I come to on the site is that education is good if all the stars align in your favor. There *are* some wonderful art schools out there! But, if you can't find a college which will fit your budget and your aesthetics, being self-taught or studying with private tutors is perfectly fine too. Most art galleries and art collectors don't care as long as they like your art. What does it matter how you got to where you are now? Either they think your work is good or they don't.

So, what is this essay about? It's not debating about whether or not you should seek a college education. If you find the right school and you can afford it, do it!

What I want to discuss now is what some of the so-called 'art elite' are trying to shove down our throats.

There's a graphic I published on my blog (portrait-artist.org/blog) which illustrates perfectly what is happening nowadays. The picture shows two drawings side-by-side. The first drawing is of a figure, looking like it came from a typical beginner student. Its anatomy is iffy and the values are flat. This drawing doesn't show a lot of knowledge of the figure. Above it is the title, "After three years at college."

The second drawing is refined, with subtle and beautiful values and a stunning understanding of anatomy and form. Above this drawing is the title, "After three *months* at an atelier." Presumably these two drawings were created by the same artist. Three years at a regular college only gave this student so-so skills. Three *months* at a private art school (an atelier) catapulted that same student into excellence.

In case you don't know what an atelier is, it's a small, more affordable private school that focuses on the traditional, classic art disciplines. There is a page on the website artrenewal.org which lists many of these private art schools.

Most of these ateliers do not offer a degree or any certification. What you get for your money is a wonderful education and very *marketable* artistic skill.

I saw a lot of lackluster work coming from students when I attended art school. The cause

for this usually originates from the Fine Art Department. Their message seems to be that skill is a bad thing. Skill is something to be looked down on, as lowly, as "competent." (At my school I had a Fine Art student sneer that word—*competent*—at me, like she'd said something dirty or profane.) Skill is something that "if you decide it's important," you can "learn on your own." Or, you're supposed to "bring it with you" when you enter a degree program, because they sure as heck aren't going to teach it to you!

I dodged a bullet because I didn't go through a hugely expensive art program which discouraged me from gaining any skills. By the time I went to art school, I knew what I wanted, and there was no way the school was going to steer me away from it.

But, what I saw then, and what I still see now, is lowered expectations when it comes to technical skills. There are students who seem to have no idea that there is so much more they should learn. Art students may appear satisfied with where they are, having no awareness of what else should be before them. In other words, they suffer from being somewhat delusional.

Before I go on, I'll add the caveat that we all are, in some respect, delusional. I certainly am. I look at the artwork I did ten years ago and much of it makes me cringe. And no doubt the artwork I do now will make me cringe just as much a few years down the road. Most of us are a little delusional, because without that, we'd fully comprehend how bad we are, and we'd be so despondent we'd give up! (I'm mostly being facetious here.)

But there's a heightened level of delusional that goes beyond that, and many art schools and colleges reinforce it, and even introduce it.

And the graphic I just described (showing three YEARS of college vs. three MONTHS of an atelier) demonstrates that.

There's no excuse for this. You go to an art school and you have a sincere interest in realistic, traditional art, many colleges will work very hard to redirect you to some other style. They'll try to make you feel low class or guilty for wanting to "settle" for mere realistic work. Or, they'll offer limited opportunities for you to improve yourself in that area, and insist that mediocre results are all that anyone can expect.

Congratulations, you have an art degree, "proving" that you are an artist, but you can't draw or paint worth a darn! And maybe you don't even know how much you don't know, and believe that things are just as they should be, that no more should be expected of you.

It's the "new normal." It's not right.

Now, if you aren't interested in what I'd call traditional, realistic art, then this doesn't apply to you. There are many other styles of art out there. I'm not here to criticize them or try to take anything away from them.

All I *do* know is that many (not all) art schools and universities are doing a pathetic job of giving students traditional skills, even though these skills are something that many students *want*. They go to school in large part to acquire these abilities, and they're being cheated. Some realize that they're being lied to and are dissatisfied with what they're able to do after they graduate. Others don't seem to recognize that they've been had. They honestly believe that they possess an adequate set of skills to compete with others who focus on traditional realistic styles. But sadly, these students aren't ready for that yet, because their school *cheated* them out of the opportunity.

Their school and their professors decided *for* them that some styles are not what any student should want. So even if a student expresses a passionate desire to work in a more realistic style, the school will take the student's money, but refuse to teach them. The school will convince them that what they want isn't what they *really* want. Or, if they can get away with it, the school will insist that the student actually did get a full and complete education in traditional skills. It's only later that the student finds out the awful truth— that they are completely unprepared, under-skilled, and unable to compete with artists who who truly studied the fundamentals (often at ateliers).

All I can say is, again, that it's not right. We're being had. We're being bilked. We shouldn't put up with it. We've been drinking the Kool-Aid, and it's time to stop.

If you want to get more information on seeking a marketable art education, do an Internet search for an article written by Noah Bradley, called "Don't Go to Art School."

## Avoid Giving Your Signature a Tacky or Newbie Look

Nothing screams "newbie" and "tacky" more than a large and elaborate signature on a drawing. Additional points go for an extra flourish or curlicue included with the signature.

The drawing on the left shows an especially grievous example of this phenomenon. The signature is too large for the drawing, invading part of the head and almost becoming the main focal point. It's obvious that the signature is carefully designed with flourishes.

The signature on the right side is written in a normal hand—not painstakingly fancy, not too large and not intrusive. For most portraits (except for oversized art) it is preferable to sign your artwork with the same size and style of writing that you normally use when signing your name. Don't make your signature look like you spent a long time getting it

just right—even if you did, in fact, put a lot of thought into it. You can place your signature in the corner (for some reason, the lower right hand corner seems typical) or you can nestle the signature somewhere on the edge of the portrait, where it is unobtrusive but still easy to find when someone is looking.

Depending on the circumstances, you should consider including a copyright (©) symbol in the signature. It never hurts to get into the habit of putting that symbol on all your artwork.

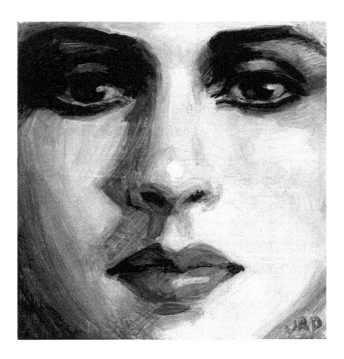

*"Eyeliner," oil on panel. No reference was used for this painting.*

## Avoid Problems, Be Honest

Most of us know instinctively that we should be honest and gracious in all our life dealings. There are specific examples of how honest behavior will apply to the artist.

In a previous essay I talked about tracing and using drawing aids, and explained why this can create problems. One of the biggest problems can be how others perceive you if you use an optical aid (to help you achieve drawing accuracy) but don't own up to it.

There are no "rules" to art. I've heard this said many times, and it is true. But, there are standards of behavior. Always being honest is high on the list of rules that shouldn't be broken.

When you are open and transparent about how you do things, you'll find that most people won't judge you harshly, even when you worry that they could—or should. So, rather than being angry because you are afraid people are judging, stop acting in a way that encourages the judgment in the first place. Be honest!

Another area where transparency is needed is the detail of whether you paint from life, use photos, or even use *other* people's photos. A lot of artists feel there is a distinction between all of these things. Never try to conceal your process here either. People *will* find out, whether you like it or not.

You'll notice that a few of the illustrations in this book give credit and thanks to a model or photographer. I sometimes use other people's photos (typically in the form of stock photography) as reference for my artwork.

There is nothing wrong with this as long as you're up front about it. Don't pretend that you painted or drew something from life when you used a photo. If you used someone else's photo, mention it if anyone assumes otherwise. Give credit when it is requested by the photographer.

This doesn't always mean that you should put a big disclaimer in front of every drawing or painting which states, "I USED SOMEONE ELSE'S PHOTO" or "I TRACED THIS"! But never let a wrong impression stand.

*"Exotic Simplicity," oil on panel. Thanks to Cathleen Tarawhiti of DeviantArt.com for the stock photo used as reference.*

## Digital Tools Can Be the Artist's Best Friend

I went to art school before computers were a mainstream creative tool. I remember feeling concerned that I'd never adjust to them. I was convinced that when digital tools became the standard, I would be left out in the cold—no *way* could I become comfortable with them!

As it turned out, my fears about using computers and graphics software were unfounded. I adjusted quite well, and now I don't know what I'd do without my digital tools.

When I first wrote this essay, over ten years ago, computers were popular but many artists still hadn't jumped on the digital bandwagon. That is no longer the case.

However, I'm still amazed how some artists don't use digital tools as much as they could—and should!

First off, when you work traditionally (pencil, pen, oils or acrylic paints) you ought to edit photos of your artwork on the computer. I see too many pictures of pencil portraits that are gray and faded because the artist didn't do some digital correction of the work.

## Ballpoint pen drawing—before and after digital editing

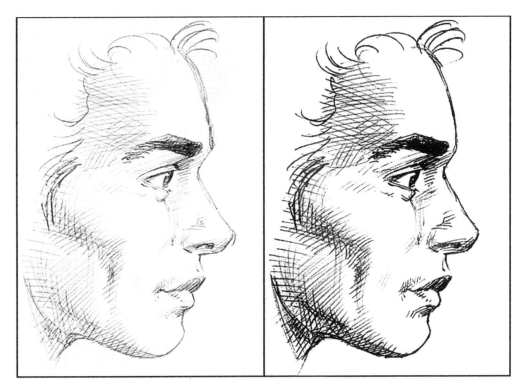

These two illustrations offer an example of an edited traditional drawing. The before picture (on the left) is the drawing as it looked right after it was scanned. It is too light, it is grayed-out, and there are smudges in the background. I drew this little drawing using a ballpoint pen on some thin scrap paper that happened to have printing on the other side. This printing showed through and I could see lines and letters bleeding through to the drawing side. Obviously, this drawing needed some editing and fixing up before I could publish it in this book or on my Website!

Because it was a ballpoint pen drawing, I wanted it to have a pen-and-ink look. Cleaning up the smudged background (with the traces of lettering showing from the other side of the paper) was my first priority. I then tweaked the contrast settings in the digital program I used (Adobe® Photoshop®) to give the drawing the pen-and-ink contrasty look I was aiming for. I also cleaned up some stray lines and got rid of errant spots on the drawing.

This kind of digital editing is often necessary with any of the artwork you create. Don't neglect to learn how to do it!

## Digital "painting" versus traditional mediums

You'll notice that all the artwork shown in this book is traditional. Mostly, pencil or ink, with an occasional painting.

When the first edition of this book was published in 2004, digital art wasn't nearly as mainstream as it is today. Back then, many artist still stuck with traditional mediums. Now it's almost reversed—digital art is, for some, the standard, and traditional (pencil, pen, oil paints) is for those who are going against the flow.

I've actually had artists view my painting studio with fascination. Ooooh, smell those oil paints! Look at the easel and the palette! Wow, what a novelty! How *different!*

How things can change in relatively few years! We now have a generation of artists who started out making art on the computer.

I made a persuasive case in the first edition of this book to embrace digital art, and I still feel that way.

But, things *have* changed.

Now, it seems like some artists start out with digital and do all their practice sketching, all their painting—everything—on the computer!

I don't recommend this. Many art professionals, even those who do mostly digital work, don't recommend this.

Start out simple. Pencil and paper. When you make a mistake, you have to erase and correct. You can't use the 'undo' keyboard shortcut. You can't fall back on the undo feature and are forced to erase and redraw your mistakes. You need to develop this discipline.

When you are working in color, learn to use traditional media first. When you mix your colors, you will be mixing them, not just selecting them in a color picker. You will learn how to smear the paint around, or blend the pastels.

It's so much easier to transition from digital after learning traditional, than it is to go the other way. I've seen some digital-only artists struggle when trying to tackle traditional media. Their digital work looks great, but their efforts with traditional look flat in comparison. Don't fall into this trap. It's not necessary! By no means am I criticizing digital media. But that doesn't mean that it's okay to neglect traditional. It will always have its place and being comfortable working in it will be an asset.

## For Traditional Artists: Dabbling in Digital

At the moment I work almost exclusively with traditional mediums. (Oils and graphite, mostly.) I sell my originals, so this is a necessity.

But, I've done my dabbling with digital work as well. It's fun! I recommend it.

One thing that you should understand is that you don't necessarily need the latest and greatest computer hardware or software to tinker with digital art. You can use old creaky computer hand-me-downs and still have great fun!

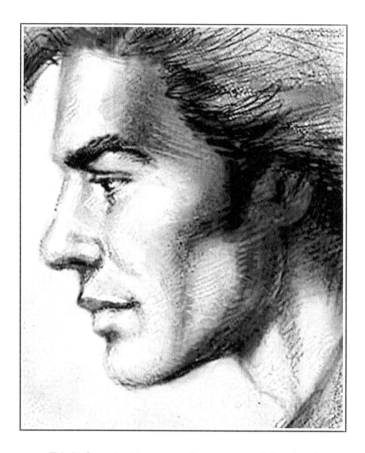

*Digital portrait — created on a PowerMac 6100*

This illustration was created entirely on an Apple PowerPC 6100. This computer was first released in 1994. I really need not say anything else!

Most of you already know that you can get a lot of work done on old hardware. I hope this little digital portrait emphasizes that point.

I believe I used Adobe Photoshop® version 4 to make the digital portrait. While it didn't have all the bells and whistles I'd prefer, it was good enough. Do you know when version 4 of Photoshop® came out? 1996! It was ancient when I was using it ten years ago, and yet it *still* packed enough of a punch to create digital art!

I would recommend without hesitation any computer that can run Adobe Photoshop®, version 7 or newer for all your digital needs. This version of Photoshop had the "heal" feature, which I couldn't live without. Photoshop 7 was released in 2002!

It's also worth noting that much of the artwork shown in this book was scanned in an Epson Perfection 3200. This scanner was first sold in 2003. While I currently use a newer scanner at home, I moved the old (but still functional) 3200 to my studio. It still works on my studio computer and produces quality results. If you are on a budget and searching for inexpensive hardware, my advice would be to find a scanner with a recognizable brand name (Sony, Epson, and so forth). Search for customer reviews of the scanner and confirm that its software and hardware compatible with your current computer set up.

Most of the time when scanning drawings and other artwork, you won't need equipment that goes much higher than 600 or 800 dpi (dots per inch). Almost all scanners made since the year 2000 (or before) can do that. So, the main concern would be picture quality and compatibility with your computer.

My point in bringing up all of this? You don't have to get the latest and greatest hardware. Your budget for digital tools can be miniscule. Buy what you can afford; it will still be good enough. Your life will be much better if you learn to use digital tools. Scan your artwork when you can. Color correct photos of your paintings. You can do it! Don't settle for low quality photos taken on your phone or other device.

As I type this, I realize that in ten years, technology will have changed dramatically. Most of the advice I give here will likely be completely irrelevant. It doesn't matter! Only remember this one thing—whatever tools we artists are using in a decade, or two decades, make sure you learn how to tackle them too. Don't be left behind.

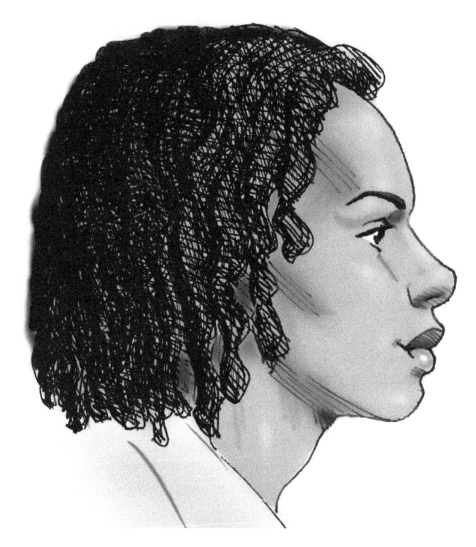

*Ink drawing with digital painting 'overlay.'*

# Introducing Color into Your Art (Painting with Color)

Since this book is printed in black and white, it doesn't make sense for me to discuss painting at length. What's the point when you can't see any example pictures in color?

But, I will make a few general points. Working in color, whether it be in colored pencil, chalk, acrylic, watercolor, or oil paint, seems to be the next step for beginner artists. Some plunge right in and tackle it right away. Others prefer to wait.

While this will not apply to every new artist, there is a tendency among some to stick within their comfort zone, particularly if they are already receiving positive feedback. For example, if someone is enjoying success and admiration for their graphite pencil portraits, they might be afraid to learn color. What if their color artwork isn't as good? What will everyone *think*? So these artists decide that it's better to stick with what they know and be judged a success, rather than try something new and risk failure.

The best way to avoid this happening to you is to start NOW! Start working in color before you become 'afraid'!

But, even if you have been working in monochromatic (black and white) for a while, it's always a good time to start with color. Don't let your pride get in your way!

## Choosing your palette (what colors to use)

A lot of artists find choosing colors to be intimidating. There are so many choices! Which ones to get?

I'm a big fan of starting out with the limited palette. This is when you use only a few pigments and learn to mix as many colors as possible from them. It's a good training experience and encouraged in some art classes. In fact, a lot of seasoned artists will revisit using a limited palette, because it's fun and gets them 'back to basics.'

© JR Dunster 2004 - 2015 portrait-artist.org

## Going ZORN

"The Zorn Palette" is becoming increasingly popular among many artists. It was introduced by the master Swedish painter Anders Zorn (1860 – 1920). He had a penchant for working with only a few colors on his palette: A white, a vermillion red, yellow ochre, and black. He was able to produce an amazing variety of shades and hues by mixing different combinations of these four pigments. This palette is well-suited for portraiture.

See more examples of art using the Zorn Palette on my site: portrait-artist.org/zorn

*"Jason (Zorn Palette)" Oil on panel (Painting is also on the back cover of the print version of this book.)*

## Further color recommendations

If you want to work with a full color palette, the conventional wisdom is to have a warm and cool variation of each primary color, plus a few earth tones, and of course white.

If you're not familiar with the terms "warm" or "cool" being used to describe color, a simplified way to explain it is this: We associate blues and greens with being cool. Red and orange are connected with warmth.

So to translate that to color, a red that has a cool tint would lean towards purple (because purple is red + blue, and we already know that blue is "cool"). A red that has a warm tint would lean towards orange (since orange is red + yellow, and yellow is "warm"). So, that translates to a magenta red being "cool," and a vermillion red being "warm."

A turquoise blue would be warm, since it leans towards green, and green is blue + yellow, and yellow is warm. A lemon yellow would be cool, because lemon leans a little towards lime (green) and green is blue + yellow and therefore cool. And so forth and so on! It takes a while to get the hang of it, but soon enough you'll be able to identify color temperature.

I could elaborate longer on color theory, but again I am reminded that this is a black and white book!

If you just want to know which tubes of paint to buy, here is a simplified list. It will work with oils, acrylics, and watercolors, though some watercolor tubes may have a different name:

**Color palette recommendations:** (You don't need to get every color listed here, just get one warm and cool of each of the primary colors, a white, and an earth.)

WHITE:

Titanium White or Titanium/Zinc White (for oils)

YELLOW:

*Warm:* Yellow Ochre, Yellow Oxide, or Cadmium Yellow Medium

*Cool:* Cadmium Yellow Lemon or Lemon Yellow

RED:

*Warm:* Cadmium Red Light or Vermillion

*Cool:* Alizarin Crimson Hue or Permanent Alizarin Crimson (never get anything titled just "Alizarin Crimson" because it will fade too quickly), or Permanent Rose

BLUE:

*Warm:* Cerulean Blue or Manganese Blue Hue

*Cool:* Ultramarine Blue

EARTH PIGMENTS:

Transparent Oxide Red or Burnt Sienna

BLACK: (optional, required if using the Zorn Palette)

Ivory Black

There are other colors that would work okay too. This list is only to help you get started!

**What mediums (types of art materials) to use**

One of the main concerns artists have when starting to work in color is dealing with the art materials. Is it too messy? Is it expensive? Are any of the materials toxic?

The mess can be contained. Wear an apron. Put a drop-cloth in your art studio area to protect the floor. Don't freak out if you things get a little out of control once in a while. Every other artist experiences the same.

I cannot speak in a technical sense about toxicity in art materials. But I shall give some common-sense advice: Most materials are fine, as long as you use *educated caution*. Look at the health label on the tube of paint of the box of pastels or pencils. Do some research about the safest way to handle the materials. Don't be overly paranoid, but avoid

carelessness as well.

You should try to balance longevity and durability with affordability. By this I mean, some art materials are super cheap and easy to use, but they fade or fall apart too soon. What is "too soon"? A decade, or less, maybe?

I can hear some of you exclaiming that you don't care if your early color work falls apart, and maybe you will be right about that. But don't count on it. I have deeply regretted using unstable and shoddy materials with some of my earlier works. Sometimes the art turned out better than I thought it would.

Never assume that you won't make anything worth saving just because you're a newbie! Since art materials can be both affordable and durable, it only takes a little homework to find something that will last a little longer *and* will fit your budget.

## Durability in art materials

What does 'durable' mean? I know that's your next question!

I've given advice early in this book for using durable materials for drawing in pencil. Always choose acid-free paper (which won't brown and fall apart in time.) With all other mediums, you need to do some homework. A starting point would be to look for the keyword "archival," which is often used to described materials that are meant to last longer or be more durable. Sometimes manufacturers overuse this term, so use precautions.

When buying paints, look for a lightfastness rating on the label. Some paints give this rating with a number of stars (four stars **** being the most lightfast and durable, and one or two stars ** being the most likely to fade prematurely). Other art manufacturers use letters (AA, A, or B) to note lightfastness.

Lightfastness means that the color will not fade over time and when exposed to sunlight. Some pigments are notoriously fade-prone, like the much-loved color Alizarin Crimson. Be sure to avoid "true" Alizarin Crimson, as it is well known for being "fugitive" (fading). Get an Alizarin Crimson "Hue" or an Alizarin Crimson which is labeled as permanent.

## Some suggestions for the new artist

There is no one-size-fits-all medium that will work for everyone. In addition to graphite pencil, I have worked extensively in colored pencils, acrylics, and oils. I'm also familiar with watercolors and oil pastels. I've dabbled a bit with regular (chalk) pastels. They're all great.

I will give one bit of strong advice: Don't immediately disqualify oils. Oils are popular for a reason. They produce rich colors and because they don't dry immediately, they are more forgiving—it's easier to blend them and correct errors.

A lot of new artists shy away from oils because they've heard bad things about them. One popular myth is that oils are toxic and dangerous. That's a gross oversimplification. A lot of art materials are "dangerous" if you misuse them.

With oils you have to use precautions, but with care your risks are minimal. (I first started painting in oils when I was in middle school and I'm still here to tell the tale!)

To avoid experiencing problems with oils, do an Internet search for "solvent-free oil painting." This means that you substitute the solvent (paint thinner, odorless mineral spirits or turpentine) for another substance that can do the same job. A popular alternative is walnut oil. Walnut oil is non-toxic, gives off no harmful fumes, and works fine with all types and brands of oil paints. You can thin your paints and clean the paint out of your brushes by swishing them in a jar of walnut oil.

I still will use some solvents in my oil painting. A favorite brand is Gamblin brand Gamsol odorless mineral spirits. This product is popular among many artists. It's not solvent-free, but with caution, it is reasonably safe and I'm feel no worry about its use.

## Use caution and be educated

When working with oil paints, be sure to deal with your oily rags or paper towels correctly. Car mechanics have to take special precautions when disposing of their oily rags, and so do you.

Oil on rags and fabric can heat up as it oxidizes. If the right conditions exist, the rags can catch fire. I am not mentioning this to scare you, but to educate you. It's rare for a car repair shop to burst into flames due to oily rags, and it's just as rare for it to happen to an oil painter. But "rare" doesn't mean "never." You must be aware of the risks and use precautions!

A good way to have peace of mind is to dispose of your oily rags in a special lidded, metal trashcan. I purchased one of the special red trashcans that the mechanics use. Problem solved! (Do further research on oily rag disposal to ease any fears and to educate yourself.)

Some artists who don't have an oily waste can will lay out any rags or towels on a flat surface to dry. They will be sure to lay them out single layer (not gathered up in a bunch). Others will wet their rags with water and place them in a zippered plastic bag. Do an Internet search to find out what would be the best way for you to deal with your rags.

Remember, don't get paranoid about it. How many times have you heard of a car repair shop bursting into flames? Just use precautions and common sense. *Educate* yourself. You'll be fine.

*My inelegantly Photoshop-traced depiction of a "Justrite Galvanized Steel Oily Waste Safety Can," currently available at Amazon.com and other retailers.*

These cans resemble my drawing above and frequently are either bright red or yellow. They are available in a variety of sizes, including a small kitchen trashcan size.

I like to preach about the virtues of oil paint, mainly because it frustrates me to see so many artists needlessly afraid of oils. But, that doesn't mean that oil paints are meant for everybody.

Working in acrylics does mean that you can avoid the worrying about your oily rags. But, acrylics tend to be less rich (the paints aren't as strongly pigmented). Their fast drying time means that there is not a lot of time to blend colors, or wipe away mistakes. However, many marvelous artists use acrylics and you can too! But again I will repeat: don't choose acrylics merely because you're afraid of oils.

*"Jason in Acrylics" A small 4x5 inch study in acrylics. Credit again goes to Jason Aaron Baca for the stock photo I used as reference. (See acknowledgements and credits at the end of this book for more information.)*

*"Still Life with Teapot on Top of Oily Waste Can" Oil on canvas panel. This will give you an idea of the size of the oily waste can I have in my studio.*

*"Quizzical," detail. Oil on cradled panel*

# A FINAL WORD

I can't end this book without leaving you with a few parting thoughts.

In the first edition of this book, I wrote in length about "Dare to be Shameless" and I guess I'm saying the same thing here too.

Shameless is when you're not afraid to try. It's you telling yourself, "What have I got to lose?" You don't worry about what other people think. You plunge ahead, not sure how well you'll do, but not caring. It's the *experience* that is the most rewarding! If you find that you're not as fantastic as you'd hoped at first, so what? You're enjoying the journey, aren't you?

I find that when people relish learning and creating, they usually end up going further. They have more patience with the learning process because they're *enjoying* themselves. Because of this, they're far more likely to eventually produce excellent work. Try to be one of these people. Have patience with yourself. Remember that every day is a good day when there is art in your life. Enjoy the experience, even if you feel like what you produced today was a failure. Remember that you didn't waste your time because you learned something. All experiences will teach you.

I like to write tutorials on a number of subjects and one thing I've encountered are a lot of people, some of them in their middle years or retirement age, who are hesitant to give themselves "permission" to pursue something creative. They have had a lifetime of telling themselves that it's trivial, it's not "real" work, and it's not for them. They are afraid that if they can't immediately produce professional-looking results, then they are wasting their time.

They'll remind themselves that they don't have *talent*! They can't do something *artistic!* It's amazing how many people have talked themselves out of something, before they even try.

And, it's even more amazing when they finally discover that they *can* do it. There are no real barriers to hold them back—and there never were.

It's all about the attitude. Relax. Enjoy all of it. Laugh off the failures. Keep on going and learn to love even the bad days! It's all part of the artistic process.

I hope you enjoyed this book and found it helpful. I've got more books planned, including something about painting. In order to keep up to date with new books or other news, please visit my site at: portrait-artist.org/book  Thanks!

*"Lady in Green," 6x8" oil on canvas panel. Thanks to WhimseyStock of DeviantArt for the photo used as reference.*

*My dad holding his favorite six-toed cat. Ink on paper.*

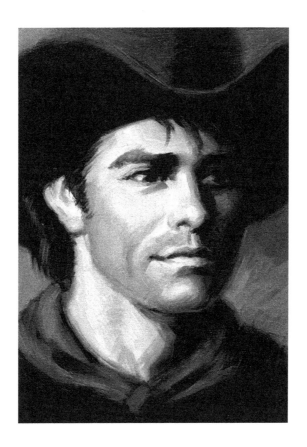

*"Ginger Cowboy,"* oil on canvas panel. No reference or model used.

# ABOUT THE AUTHOR

I'm convinced that most people don't care about the author. Why do I even have this page? Oh well.

For the two of you who are actually interested, here goes: I am a native of Southern California and went to art school at Otis College of Art and Design (www.otis.edu). I've always loved drawing people and have created a lot of portraits in my day. Some celebrities even have my art in their collections. I suppose that most Southern California portrait artists have created some celebrity portraits. It comes with the territory!

I originally got the idea to write a book about drawing way back when I was in art school. I remember telling my dad, "I'm going to write a book." He laughed. Not because he had no faith in me, but because it seemed so far-fetched of an idea at the time. Back then self-publishing was not a common thing. Who could have anticipated that it would become so easy and affordable to write and design ones' own book?

Working on this book has definitely been a labor of love and a grand obsession. I have stayed up until the wee hours—writing, sketching additional art and scanning it into Photoshop, writing new chapters on the fly, and so forth.

What a fun adventure this project has been!

Currently I am working as a fine artist. The majority of my art is portraiture and animal portraits in oils. I work in a little art studio (which I affectionately call "The Shabby Studio") where I occasionally give lessons.

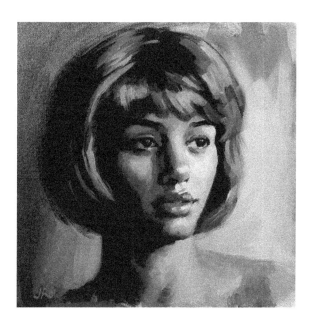

*"Blue Hair" Oil on canvas panel. Thanks to photographer Cathleen Tarawhiti for the reference photo used as inspiration.*

# IMPORTANT ACKNOWLEDGEMENTS & CREDITS

Thanks to the model Jason Aaron Baca (jasonaaronbaca.deviantart.com) and photographer Portia Shao (positivevista.com) for the reference photos used to draw or paint any artwork entitled "Jason." My gratitude goes to New Zealand photographer Cathleen Tarawhiti, of cathleentarawhiti.deviantart.com her the use of her stock photos. (All paintings which used Cathleen's stock photos as reference are credited on the same page as the art appears.) Thank you to WhimseyStock of DeviantArt for the reference photo used in "Lady in Green" (also seen on the back cover of the print version of this book).

I have also used some photos from posespace.com for a few of the paintings seen in this book.

Most of the drawings in this book are drawn without any model or reference photo. Several other artworks are drawn or painted from life.

# ABOUT THE SECOND EDITION

Nobody cares! I know this, but in case a handful of you are curious, here I will ramble on in a gratuitous manner.

I created the first edition of this book in 2003-2004 on an old Apple PowerPC G4 "Digital Audio" Macintosh. Yes, I still have that Mac. I haven't used it in a few years, but it's plugged in and ready to go in case it is needed. I used an older version of Adobe InDesign and Adobe Photoshop with this G4.

Remember how I was saying in the "Digital Tools are an Artist's Best Friend" essay, how you can get a lot of work done with old hardware? Well, this book is living proof of that. While I used a newer computer in creating the second edition, much of the backbone of this book was built on that old 533 MHz PowerMac. If I had to, I could have created this new edition on that same machine.

I currently use a Intel Mac Mini (late 2012 model) with Adobe Photoshop CS6, Microsoft Word 2016, and Adobe InDesign CS4. (But I could have used Photoshop 7, InDesign CS, and that old PowerMac. Yes I could!)

The first edition was published in early 2004, using a print on demand (POD) publisher. From my site, I linked to my book's page on the publisher's site, and my site visitors would buy the book directly from them.

When I started gathering together the files and materials needed to make this second edition, I realized a horrifying thing. Some of the backup CDs had become corrupted! I had lost many of my picture files. The sketchbooks which contained the original artwork were still around, but I dreaded the idea of re-scanning and processing each drawing. But, I had a stroke of good fortune and found an intact digital file with high resolution copies of all the original graphics. Thank you God! (I mean that sincerely!)

I replaced quite a few of the sketches, added some new ones, but many of the words and drawings remain the same.

Working on this book was a labor of love. I thank everyone who encouraged me, and my gratitude goes out to the visitors of portrait-artist.org, who have helped make all of this possible.

*"Roman Youth," oil on canvas panel. Thanks to Jason Aaron Baca of DeviantArt and photographer Portia Shao for the reference photo used.*

# BIBLIOGRAPHY

Brookes, Mona. *Drawing for Older Children and Teens: A Creative Method That Works for Adult Beginners, Too* (J.P. Tarcher)

Dodson, Bert. *Keys to Drawing* (North Light Books)

Edwards, Betty. *Drawing on the Right Side of the Brain* (J.P. Tarcher)

Hamm, Jack. *Drawing the Head and Figure* (Perigee)

Hogarth, Burne. *Dynamic Figure Drawing* (Watson-Guptill)

Loomis, Andrew. *Figure Drawing for All It's Worth* (Titan Books)

Loomis, Andrew. *Drawing the Head and Hands* (Titan Books)

Peck, Stephen Rodgers. *Atlas of Human Anatomy for the Artist* (Oxford Press)

Ryder, Anthony. *The Artist's Complete Guide to Figure Drawing: A Contemporary Perspective on the Classical Tradition* (Watson-Guptill)

CPSIA information can be obtained
at www.ICGtesting.com
Printed in the USA
BVHW01s2136140718
521639BV00004BA/226/P